U0011465

角頭

台灣江湖上從屬較大幫會的街頭分支，多分支可同時作業，亦稱「街角頭目」。

GATAO

Gatao is a part of the Taiwanese triads, it is a street level branch in a bigger triad. And there are several branches working in parallel.
Gatao can be translated as "the street corner leader"

真誠感謝張威緒先生邀我參與第二部角頭電影《角頭2：王者再起》的拍攝，他致力用「角頭」打響台灣黑幫電影的名聲，令人倍感榮幸。自由紀錄所見所感，對我是一場全新的經歷 — 片場初體驗，由角頭製作關於角頭的角頭電影，由實際角頭上場的戲，以非角頭和角頭構成的場景。全為完成這部作品齊心戮力。此外，還要感謝片場所有的人，你們的協助讓我得以放手發揮。
此攝影集以一些台灣角頭電影慣有的主題進行編排。

Per Jansson　致敬

First of all, I would like to express a great thank you to Mr. Red Chang who invited me to the shooting of his second gatao movie, Gatao 2 - New Leader Rising. Mr. Red Chang is determined to make a brand name of gangster movies from Taiwan under the name Gatao and it is a great honor to be able to participate in a part of this project. I was free to do whatever I wanted during the shooting, just document my impressions. For me this was a totally new experience. First time on a filmset and then a gatao movie which is about gatao, produced by gatao, partly played by gatao and the whole filmset is a mixture of gatao and not gatao. All working together for the movie. Secondly, I would also like to thank everybody I met on the filmset. Everybody was very helpful in helping me to work freely on the set.
I have organized the pages in this book under some of the categories that will always appear in Taiwanese gatao movies.

My sincerest gratitude
Per Jansson

我也要感謝電影公司理大國際多媒體公司幕後工作人員和在公司裡工作的每個人。我還要感謝齊石傳播公司以及在那裡工作的所有人，尤其是介紹我認識電影和電影公司老闆張威緒先生的Tina Yin。我還要感謝所有激勵我完成本書的人。 我要感謝與我已有30年友誼的荷蘭攝影師Yani，他為我提供了珍貴的反饋。我也要感謝台北攝影師David Thompson，他為我提供了珍貴的意見。

I also offer my thanks to the main company behind the movie, Leday Multimedia, and everybody working there. My thanks also goes to Key-Stone Communications and to everybody working there and in particular to Tina Yin who introduced me to the movie and to Mr. Red Chang. My thanks also goes to everybody who has inspired me to finalize this book. My thanks goes to the Dutch photographer Yani who provided me with valuable feedback, as he has always done throughout our 30 years of friendship. My thanks also goes to Taipei based photograher David Thompson for his advice.

角頭 - **GATAO**

文字與攝影 - Text and Photo: Per Jansson

給我的妻子 - To My Wife

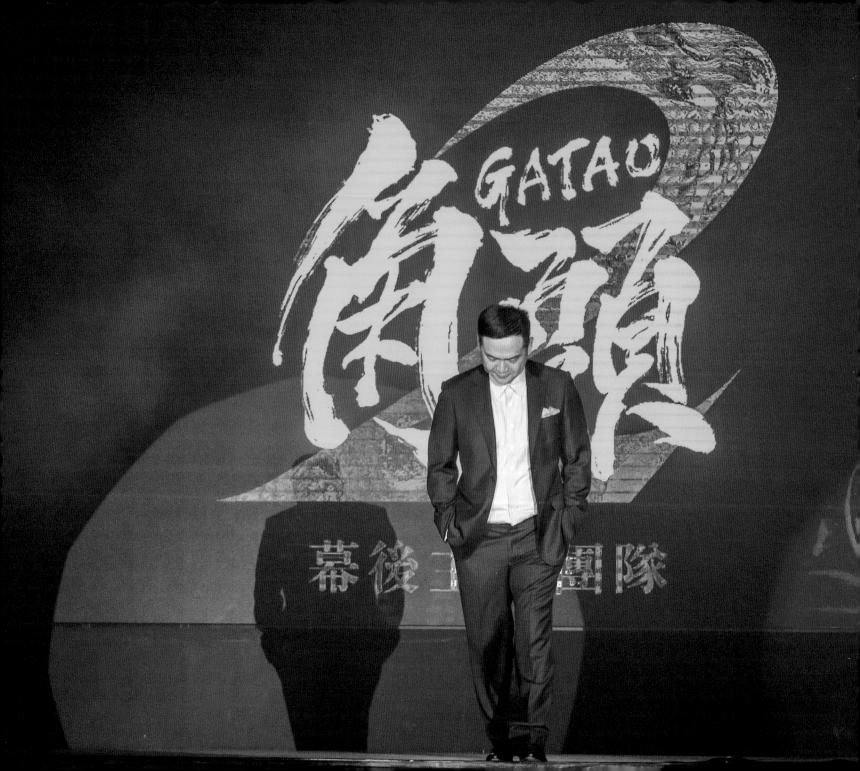

電影人

左為張威繢現身首次記者會。伸展台上清一色的男性，強調角頭是男人的世界。

Movie Makers

To the left, Mr. Red Chang at the first press conference.
Gatao is a man's world which was emphasized on the first press conference by showing only men on a gatao catwalk.

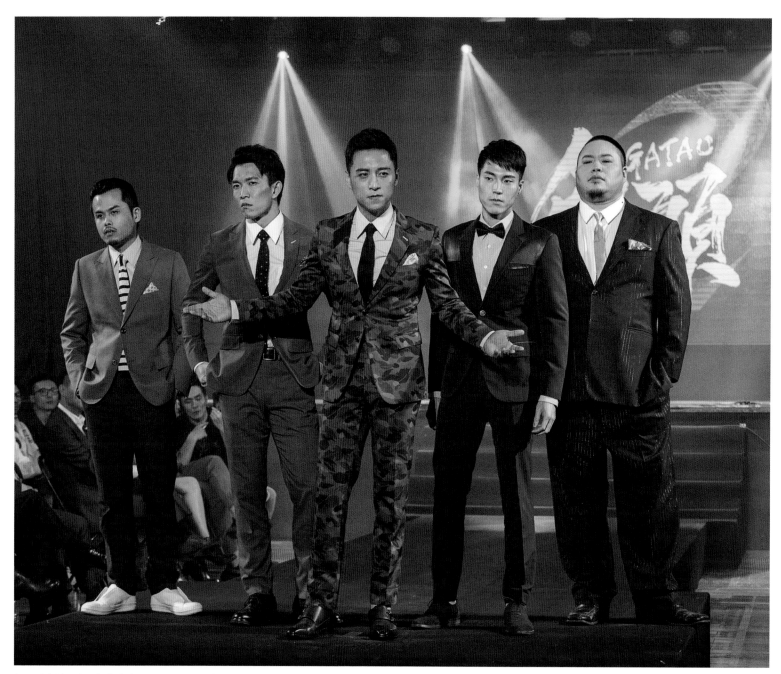

上：男演員；右：好萊塢演員鄒兆龍；下一跨頁：製作人、導演、演員、劇組組長
Above: Male actors on the catwalk; Right: Hollywood actor Collin Chou on the catwalk;　Next spread: Producers, director, actors and crew leaders

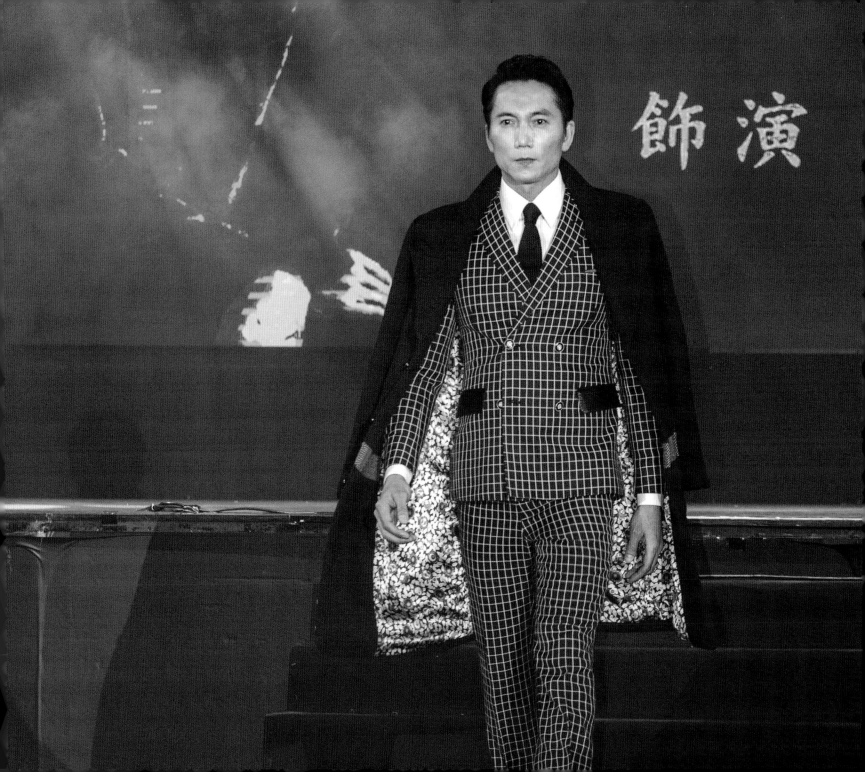

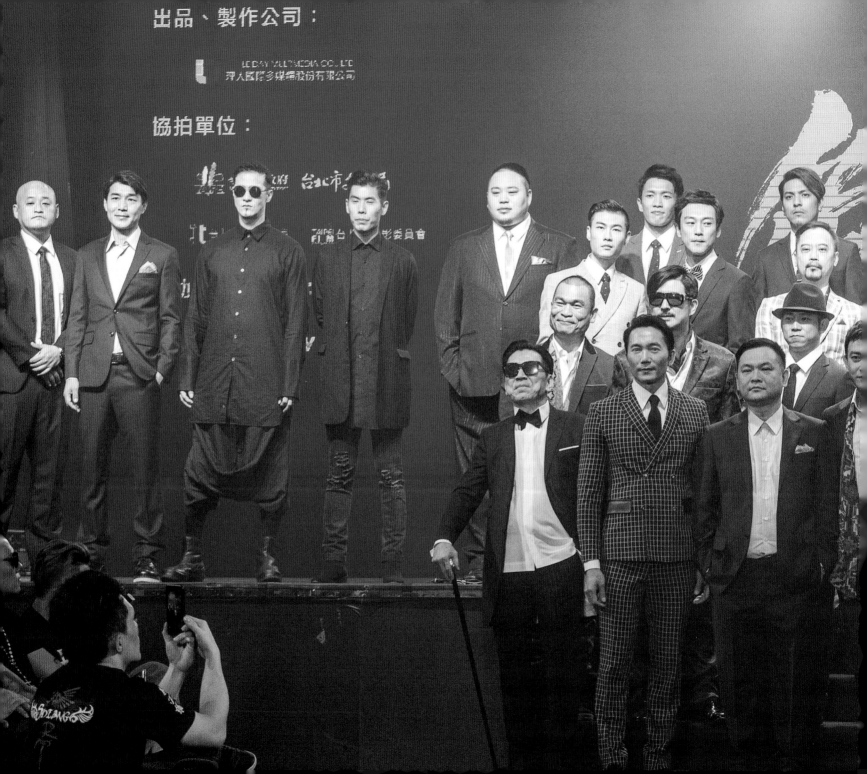

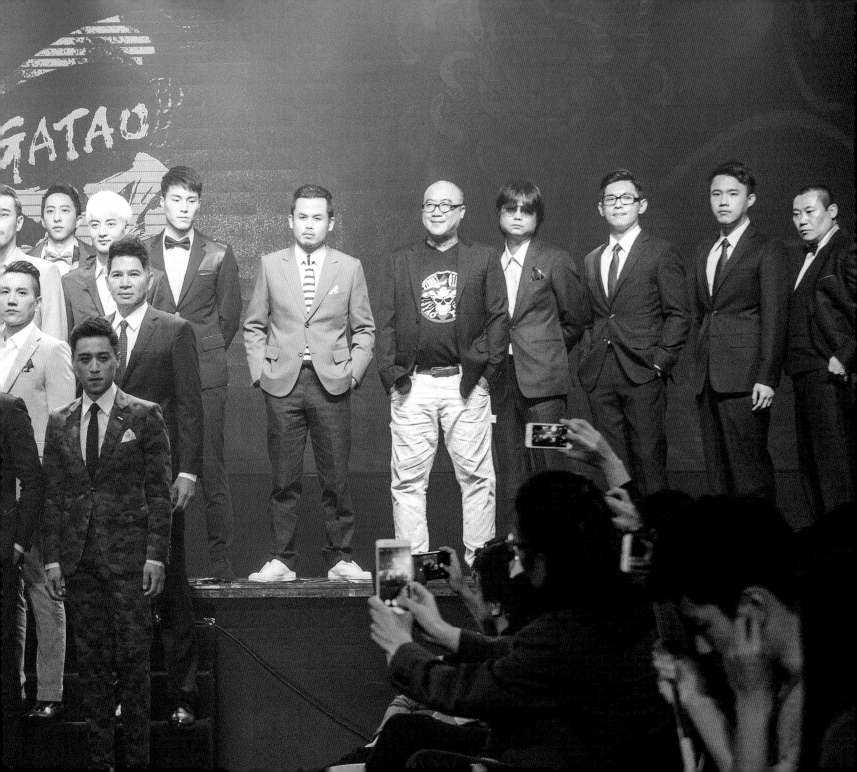

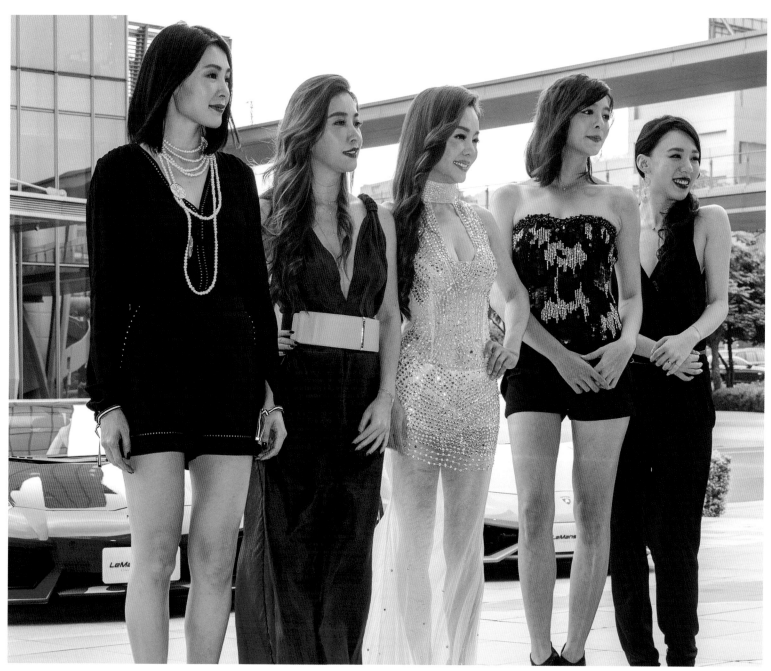

上：女演員出席記者會；右：首映前登台的製作人、導演及最終版裡的男女演員
Above: The female actors at their press conference; Right: On stage just before the premier, producers, director and female and male actors in the final version

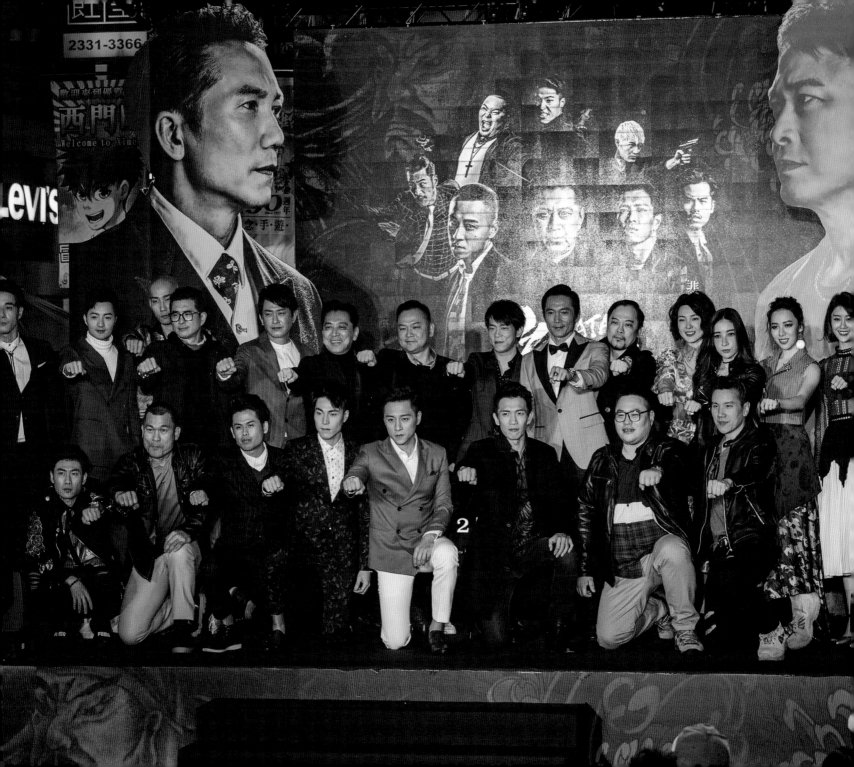

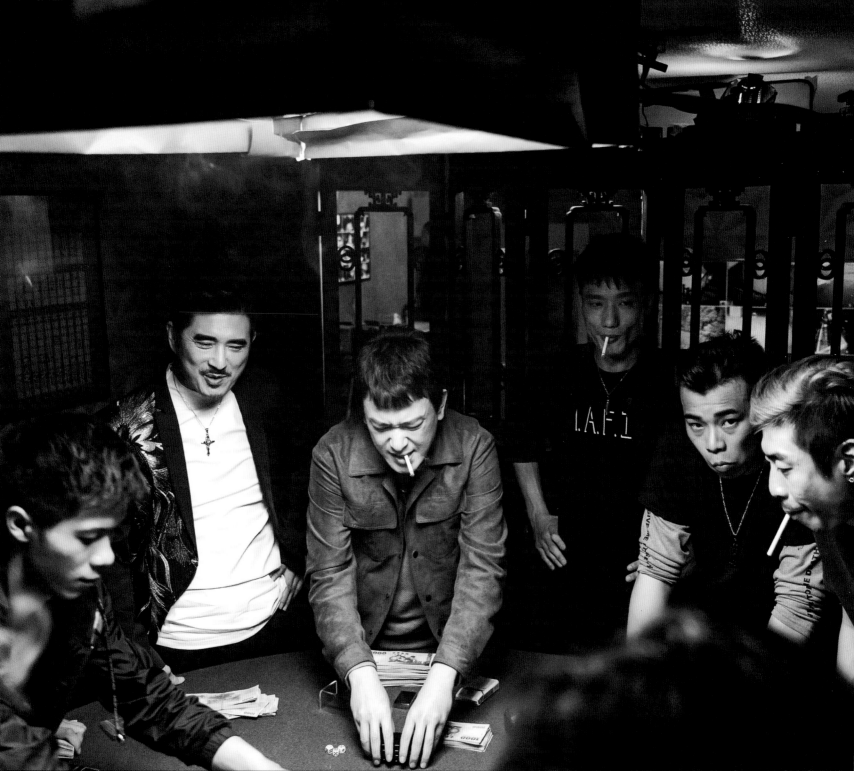

角頭2 劇情

角頭老大仁哥的地盤以賭博為主，碰到幼時好友劉健找上門。兩人半夜在101大樓附近會面，劉健對著天空開槍以示威脅，盤算藉由入獄了解各幫、建立人脈、奠定地位和開創新勢力。出獄後的劉健以毒品販賣為金源，用廝殺挑戰既有規矩。

The Story of Gatao 2

Ren is running his branch of gatao, mainly involved in gambling when his old childhood friend, Jian, calls him up and wants to meet up. Ren goes to meet him in the middle of the night life around the 101 building. Jian threatens him with a gun and fires in the air. Actually Jian only wants to be imprisoned to learn about the triads, build a network and see where he can fit in and create his own turf. Later Jian will come out of prison, go into drugs and challenge the given order with executions and fights.

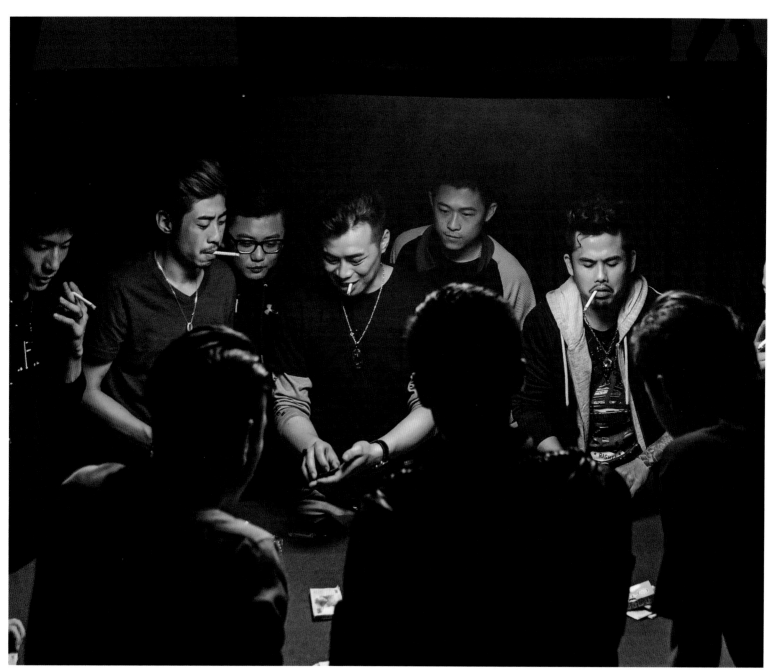

演員和角頭兄弟賭博；右：劇組於台北101大樓
Actors and gatao boys playing themselves at the gambling table; Right: Taipei 101 building with film crew

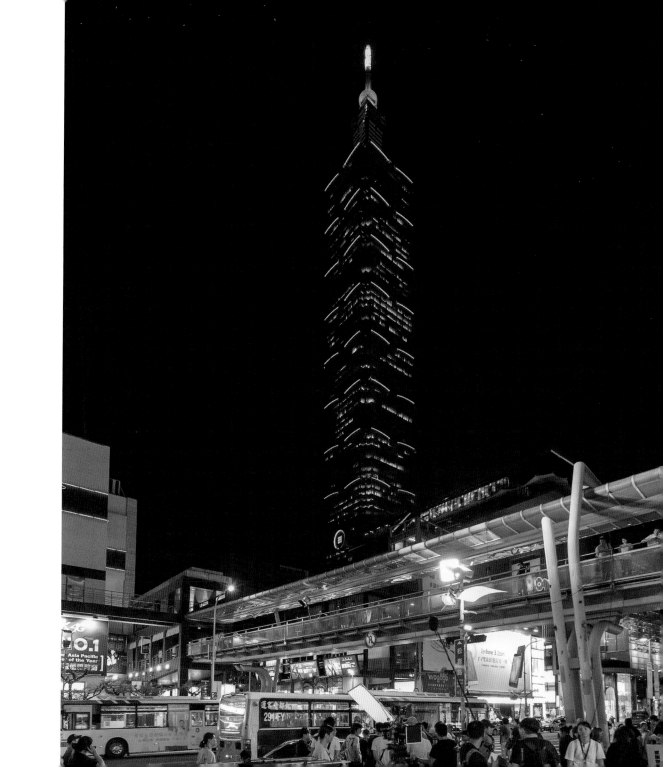

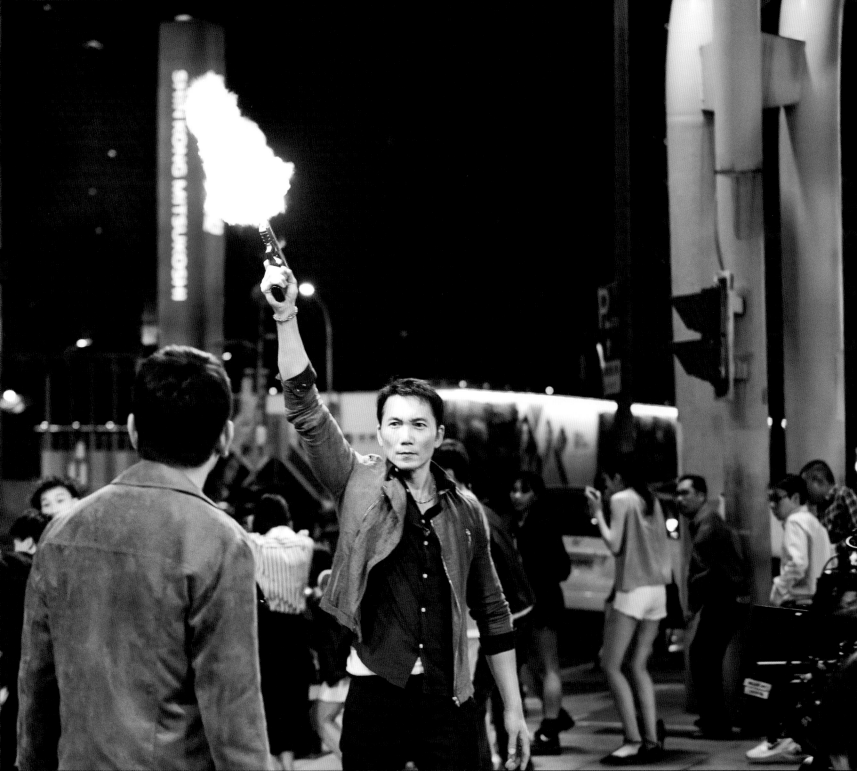

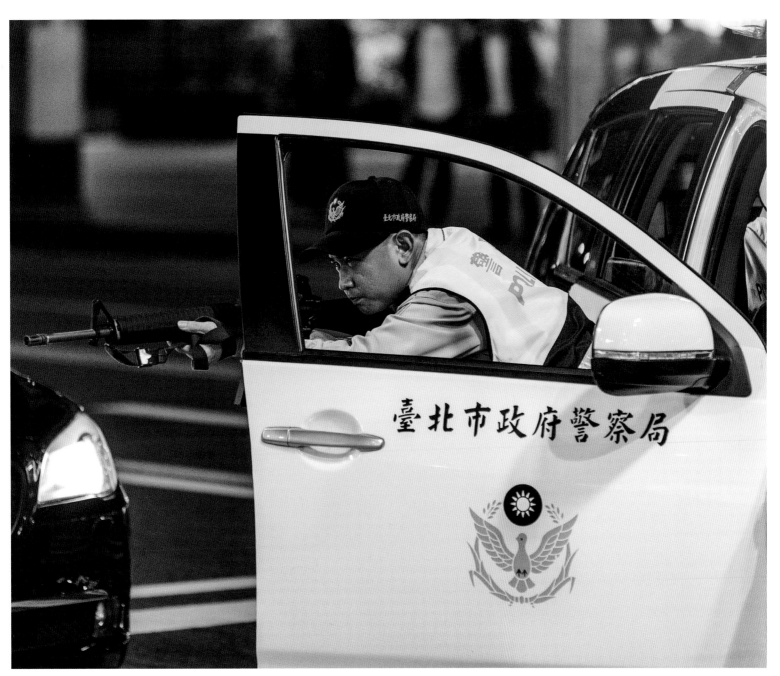

左：劉健（鄒兆龍）因開槍入獄；上：台北警察；下一跨頁左：燈光組；右：劉健遭逮補
Left: Jian (Collin Chou) fires to go to prison; Above: Taipei police; Next spread left: Lighting crew; Right: Jian is taken to custody

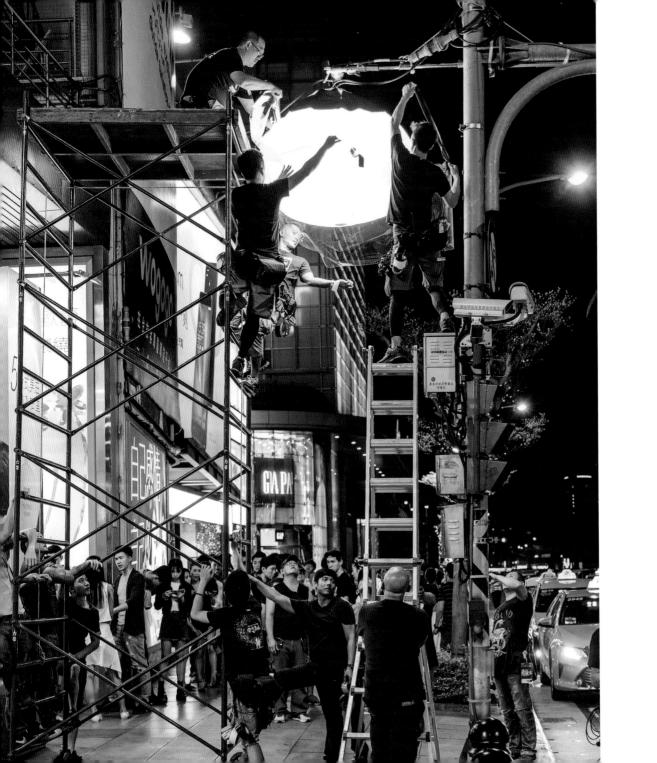

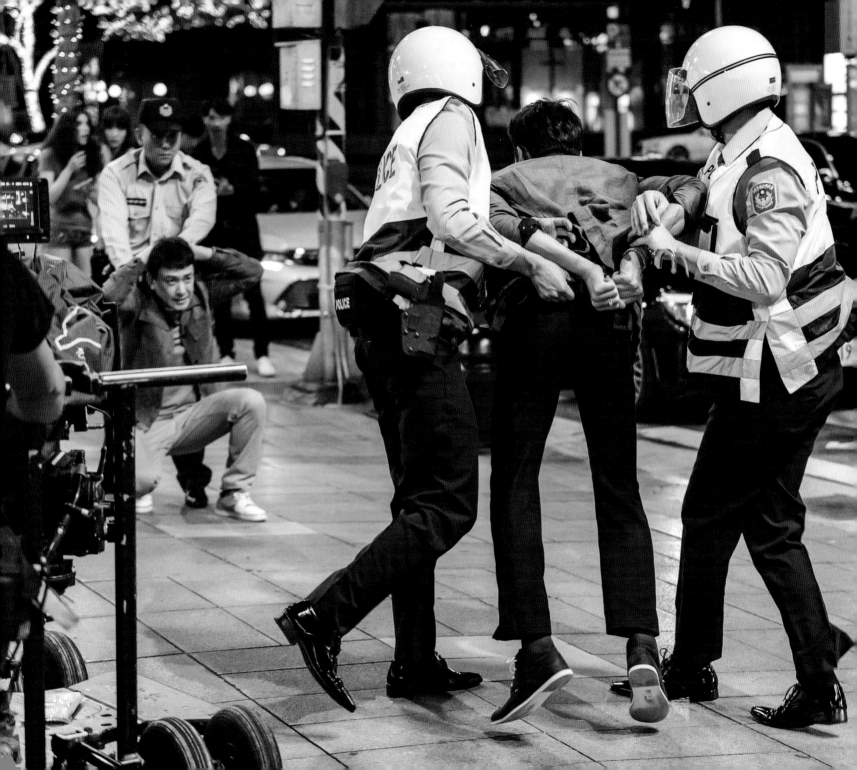

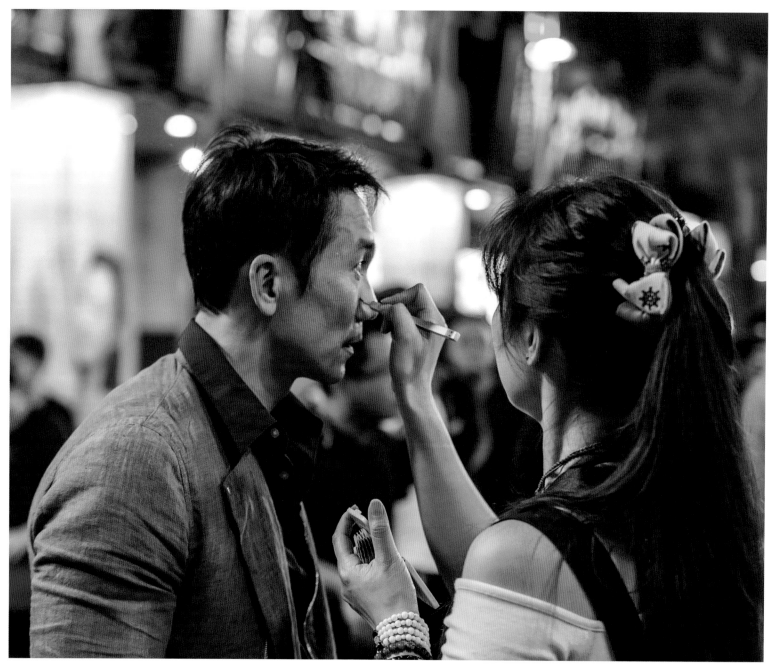

上：化妝；右：燈光及攝影組
Above: Make up; Right: Lighting and camera crew

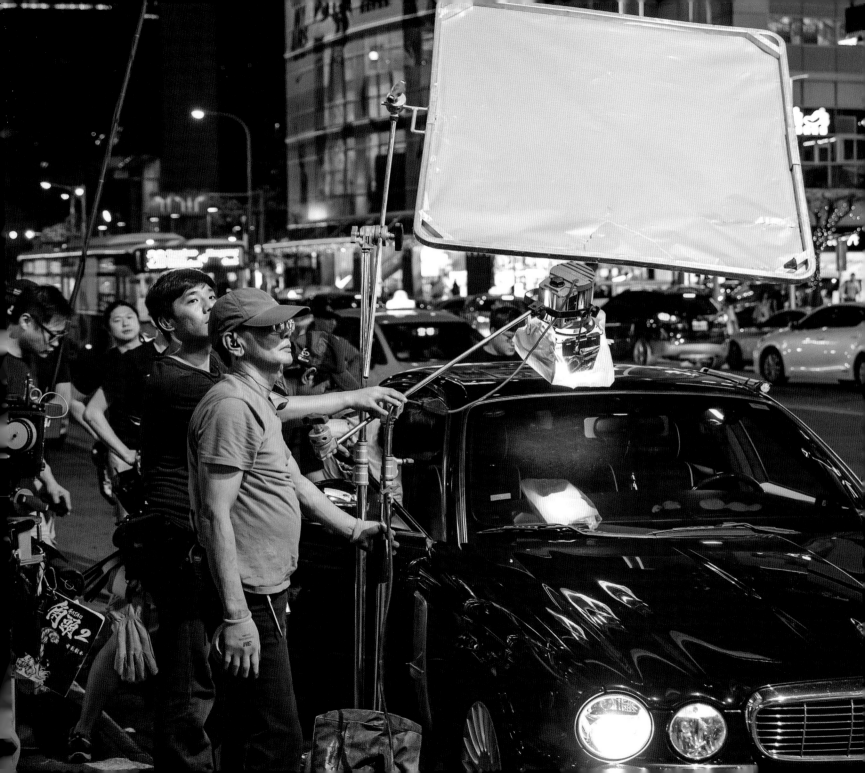

林森北路

台北地下世界的一條重要街道，出遊和經商的地點，不屬於特定幫派，多方垂涎稱霸。這裡是一般人眼中的紅燈區，賦予鬥爭真實的背景。

Linsen beilu

Linsen beilu is an important street in the underground world of Taipei. It is a place for going out and a place for running business. Linsen beilu does not belong to one certain group and ownership is represented by many interests.
To an ordinary visitor it looks very much like a red light district and it provides a genuine backdrop for rivalry.

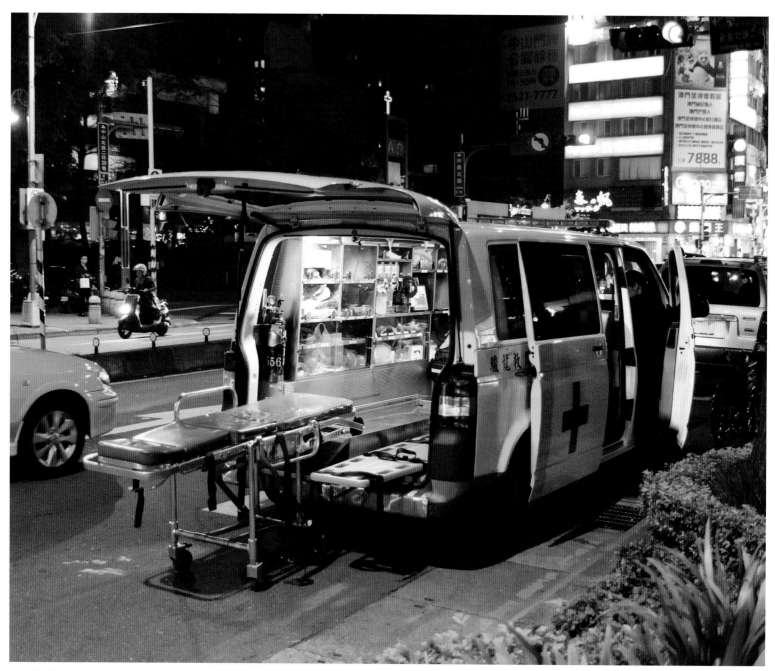

上：救護措施以防萬一；右：打鬥用的軟管
Above: Security measures in case something goes wrong; Right: Soft pipes for the real fighting

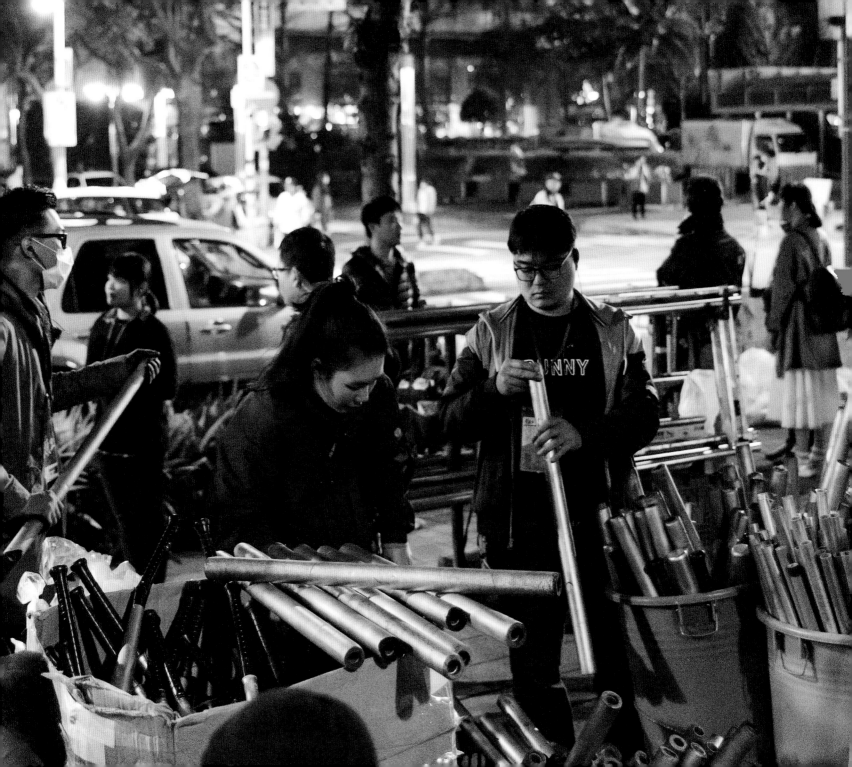

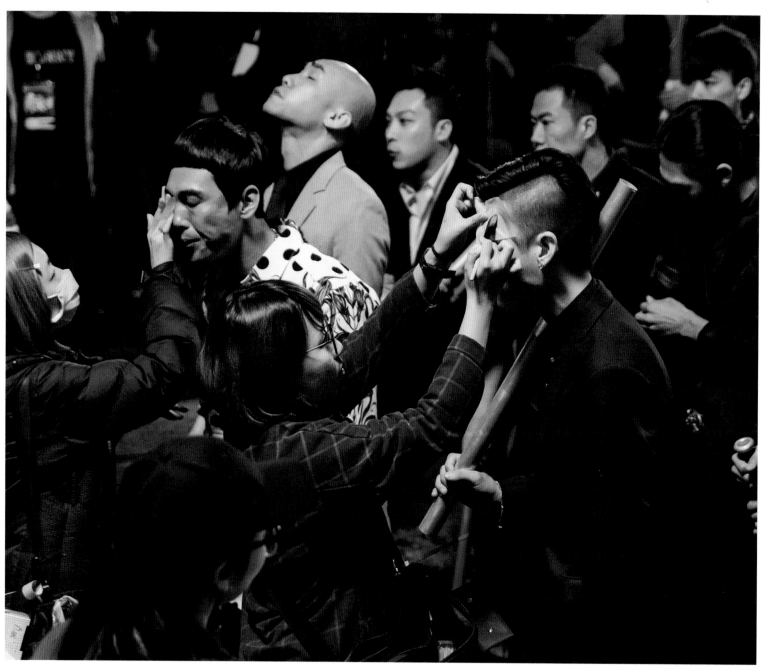

上：演員和角頭兄弟化妝中；右：準備打鬥
Above: Actors and gatao boys getting make up; Right: Getting ready to fight

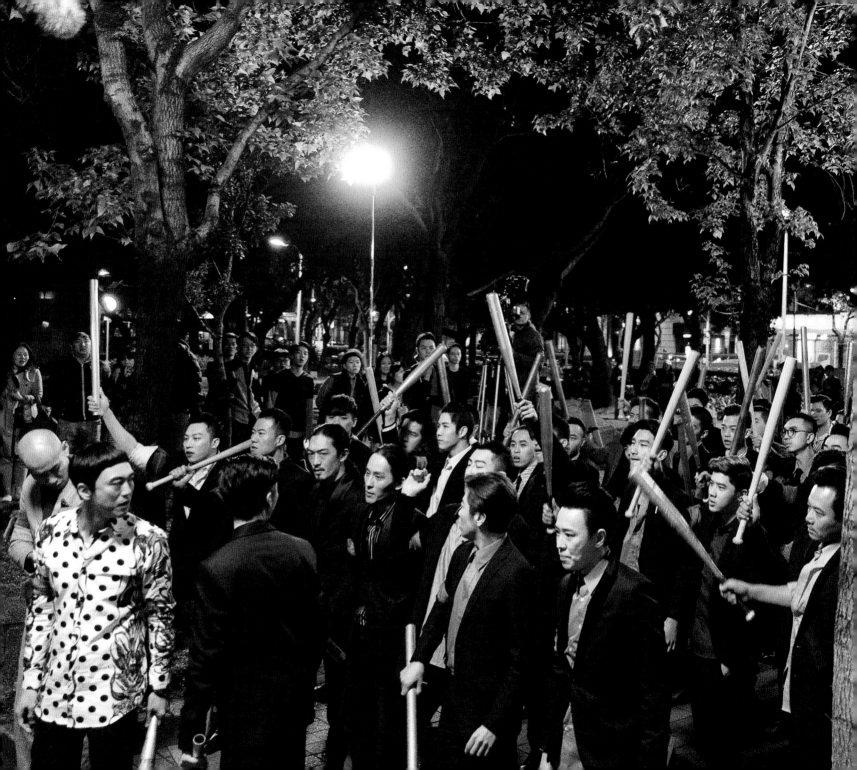

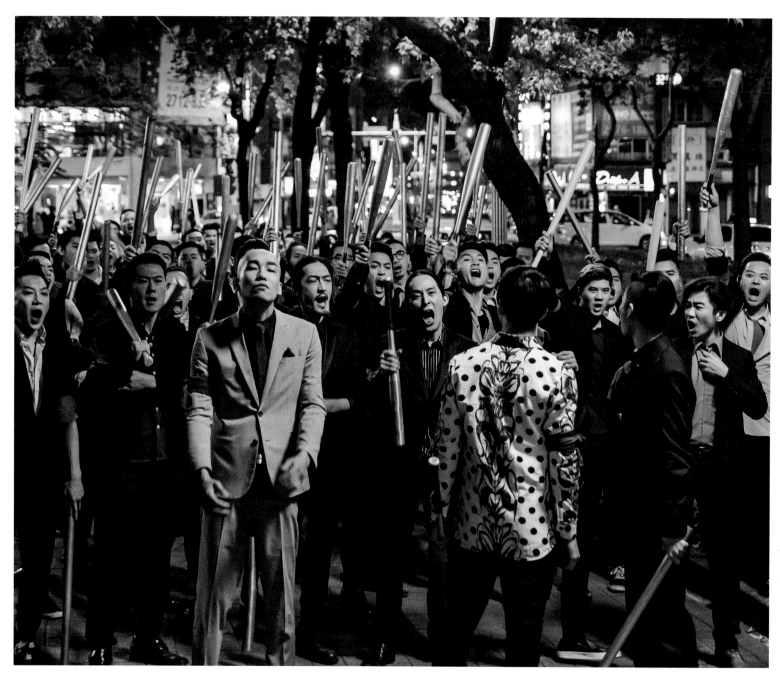

上與右：即將正面交鋒
Above and right: They will soon face each other

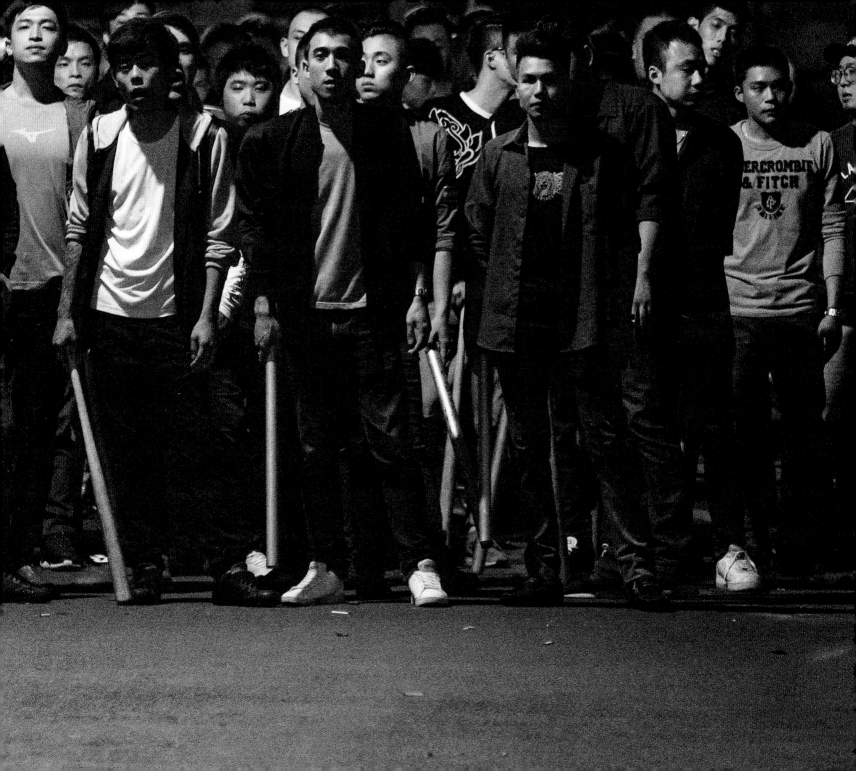

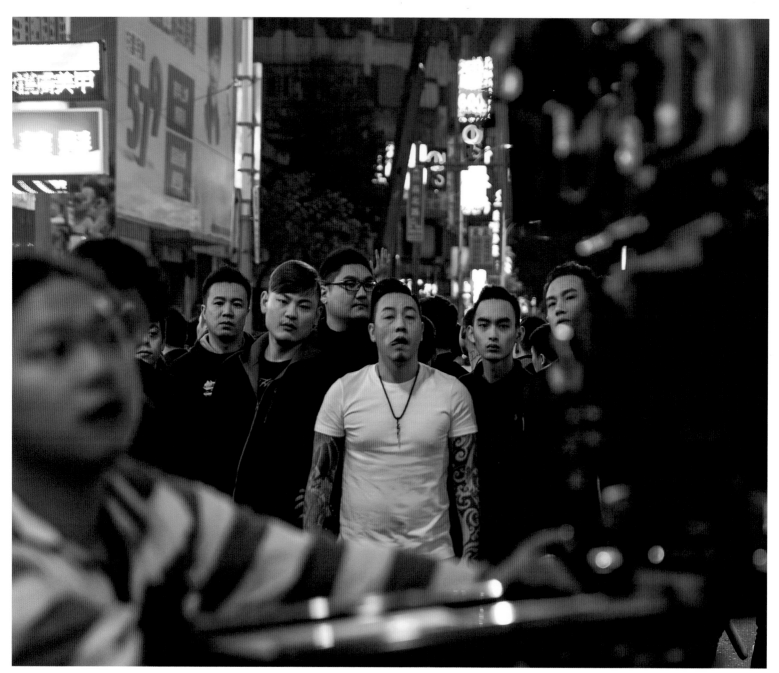

鼓足士氣
Building up for fighting

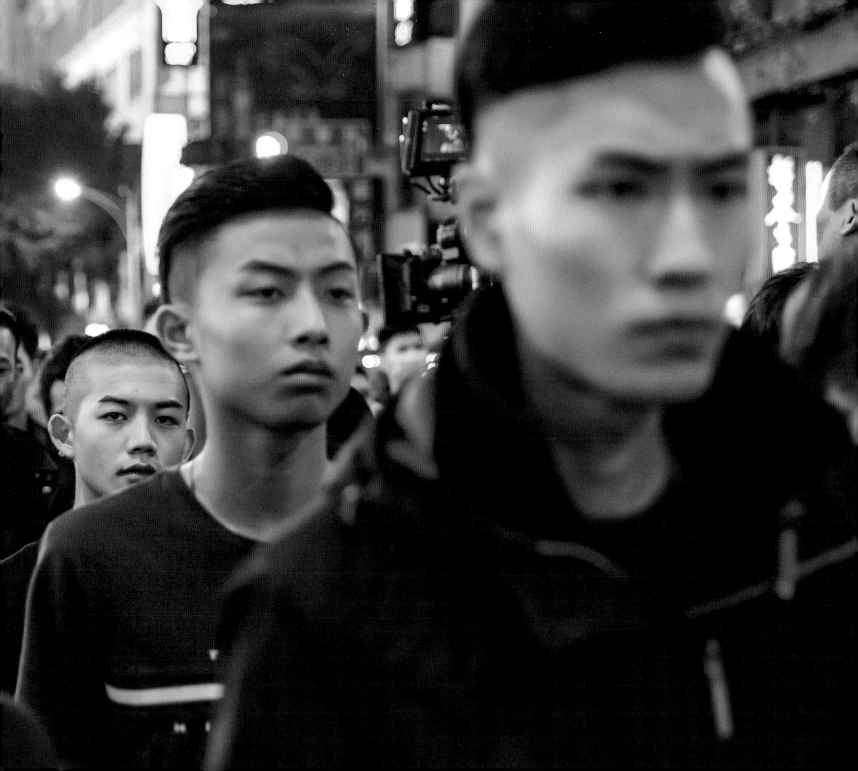

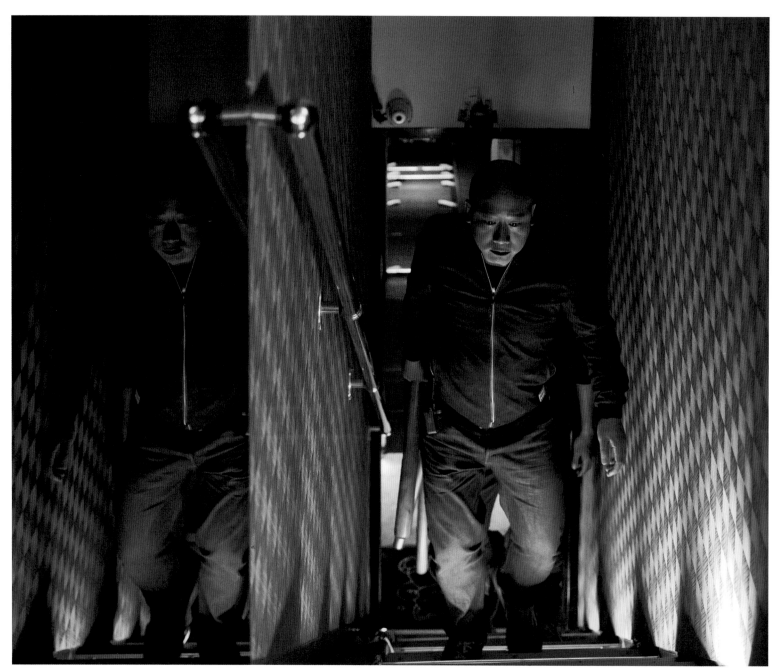

上吧……
Here we go…

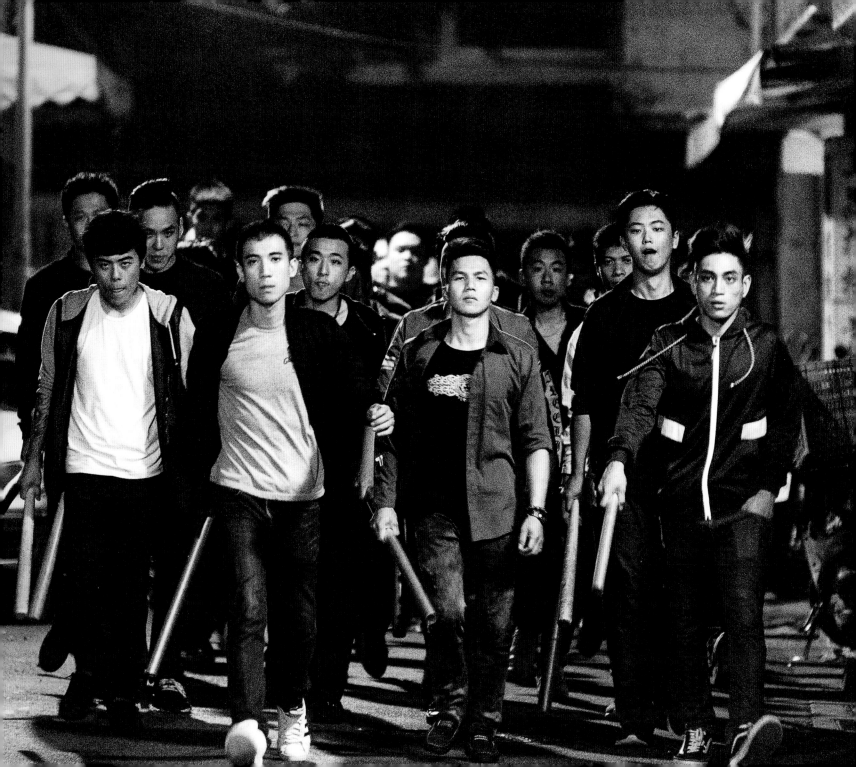

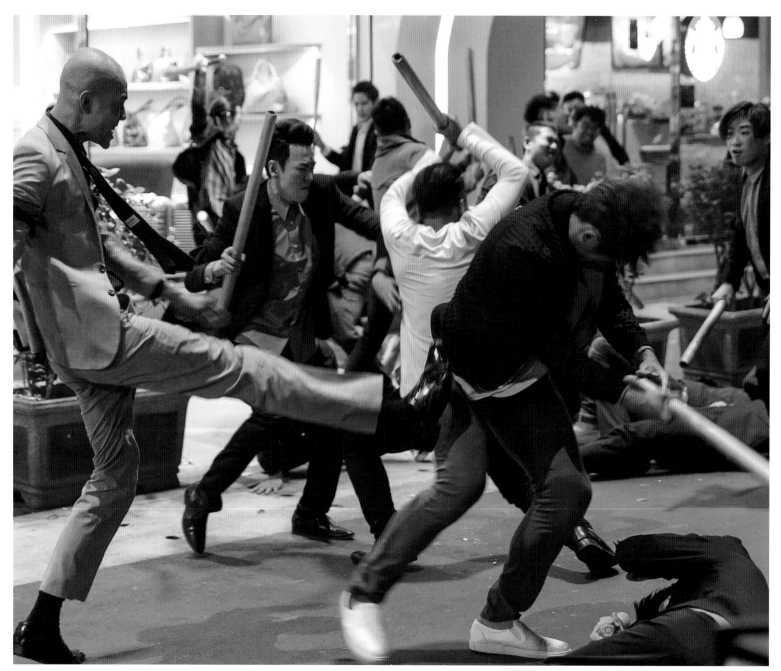

上：演員和角頭兄弟們；右：韓國武術指導（橘衣）
Above: Actors and gatao boys; Right: The Korean fighting choreographer in orange

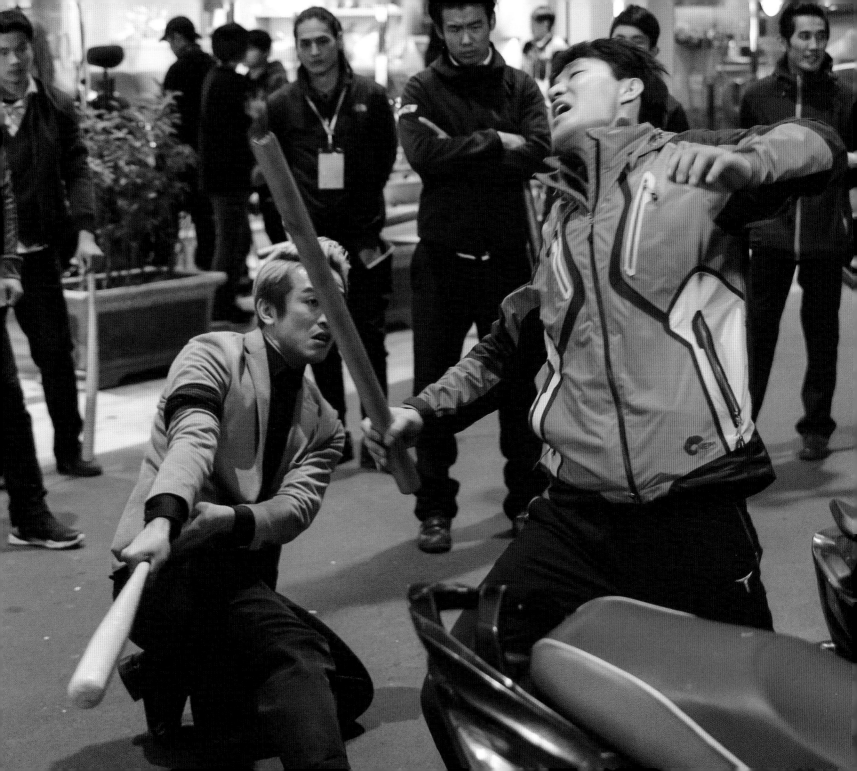

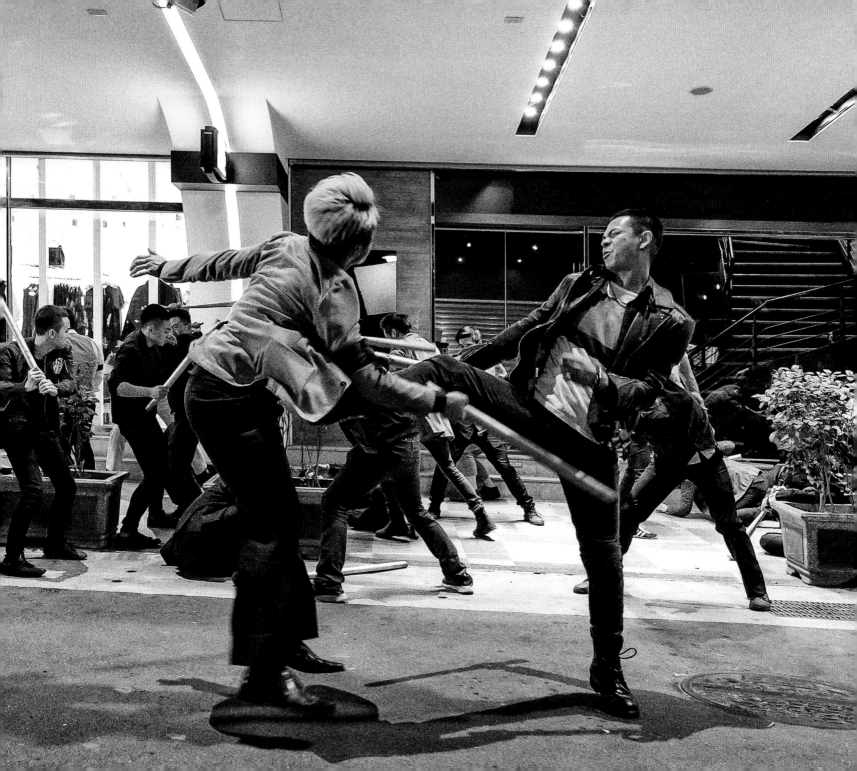

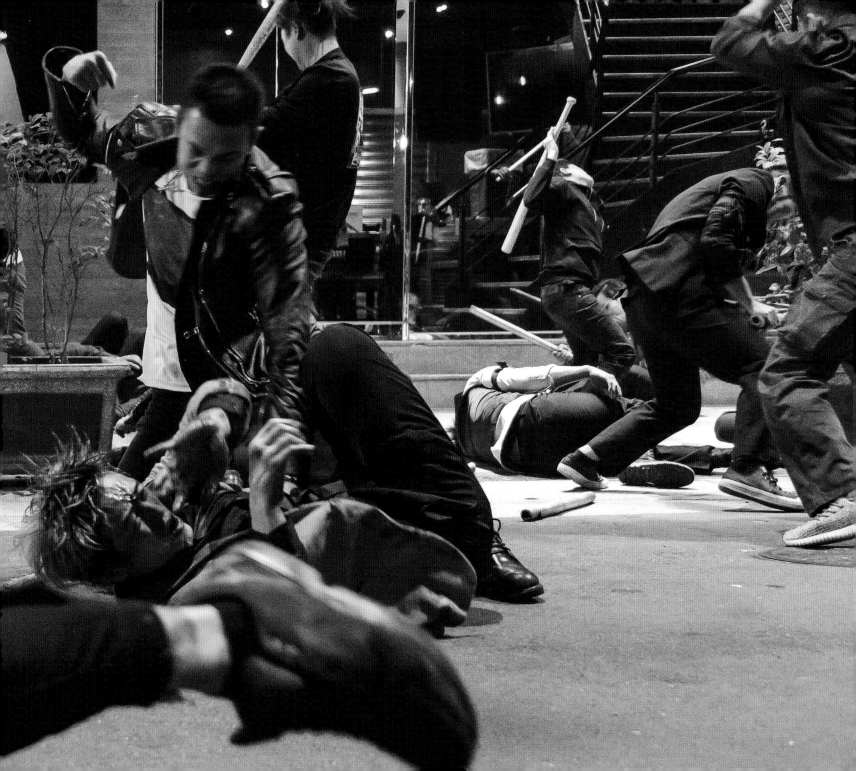

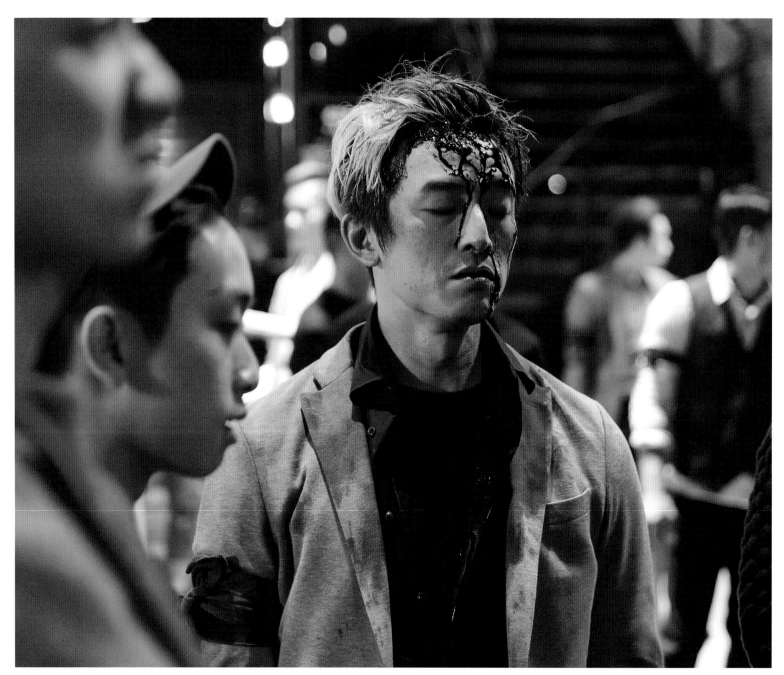

右：打戲場邊
Right: Sideline of fighting scene

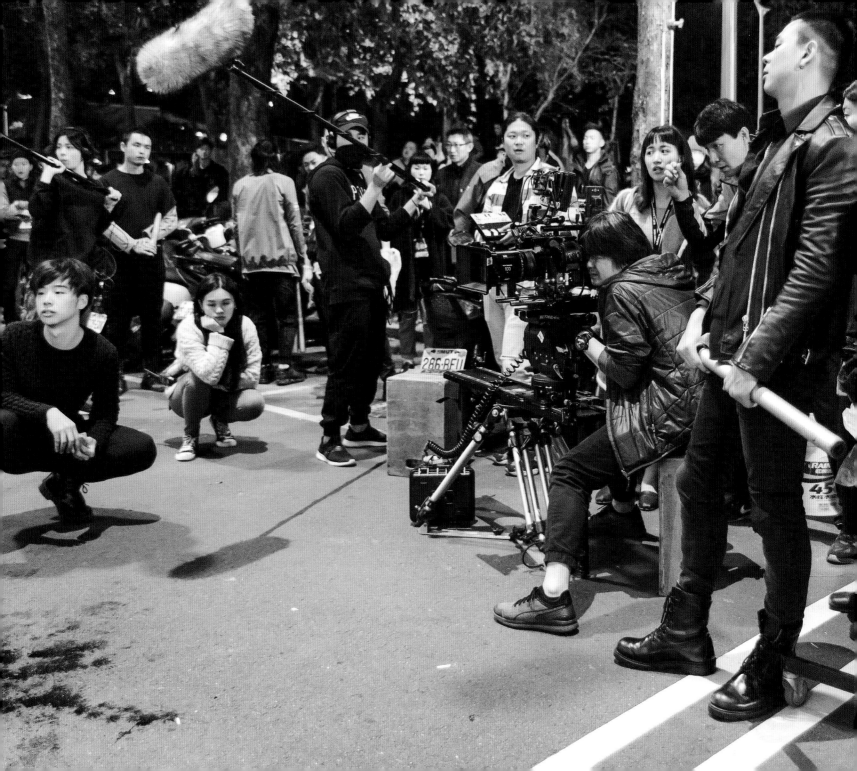

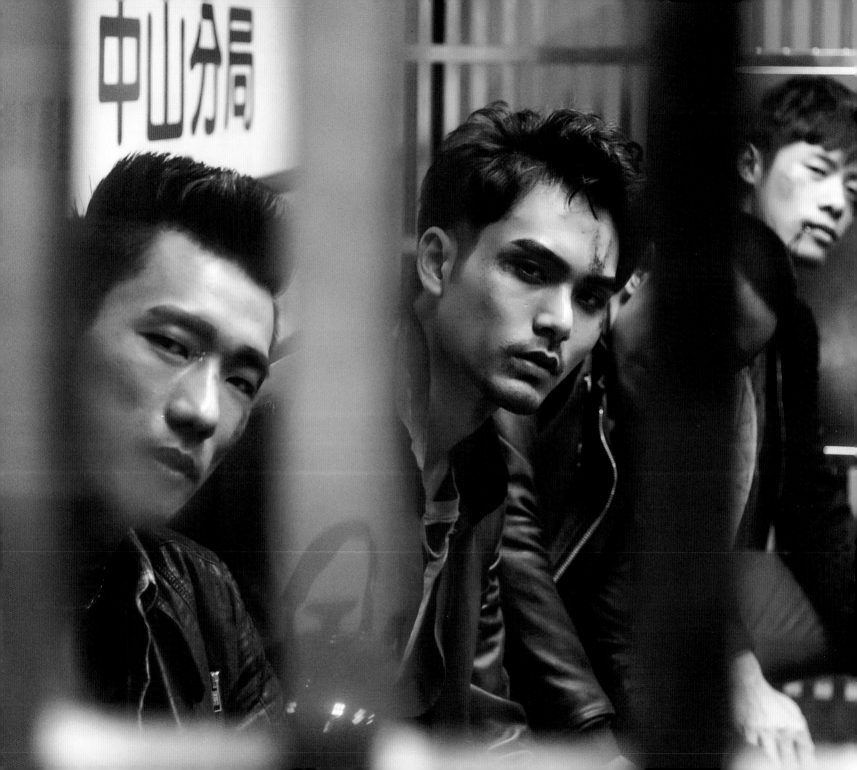

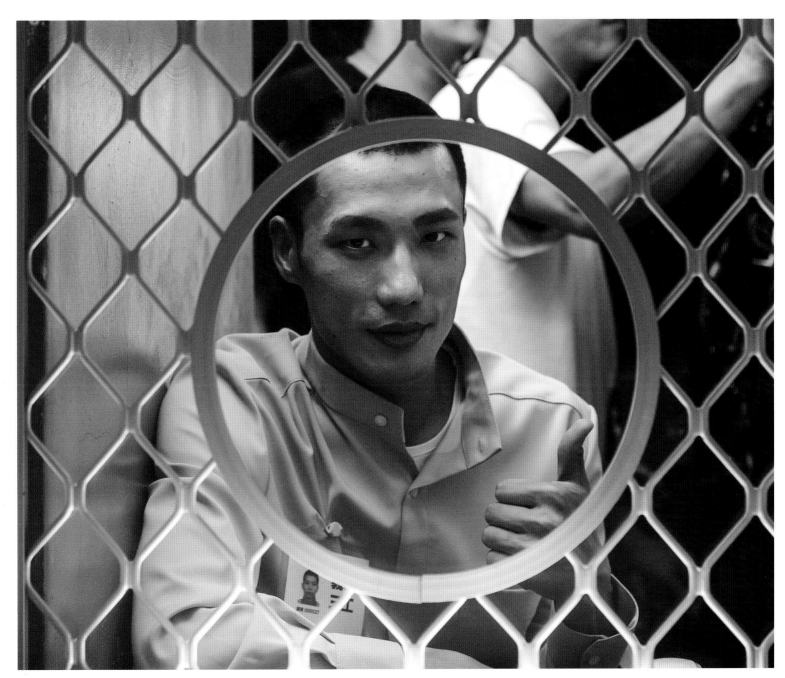

左與右：漏網鏡頭
Left and above: Got picked up

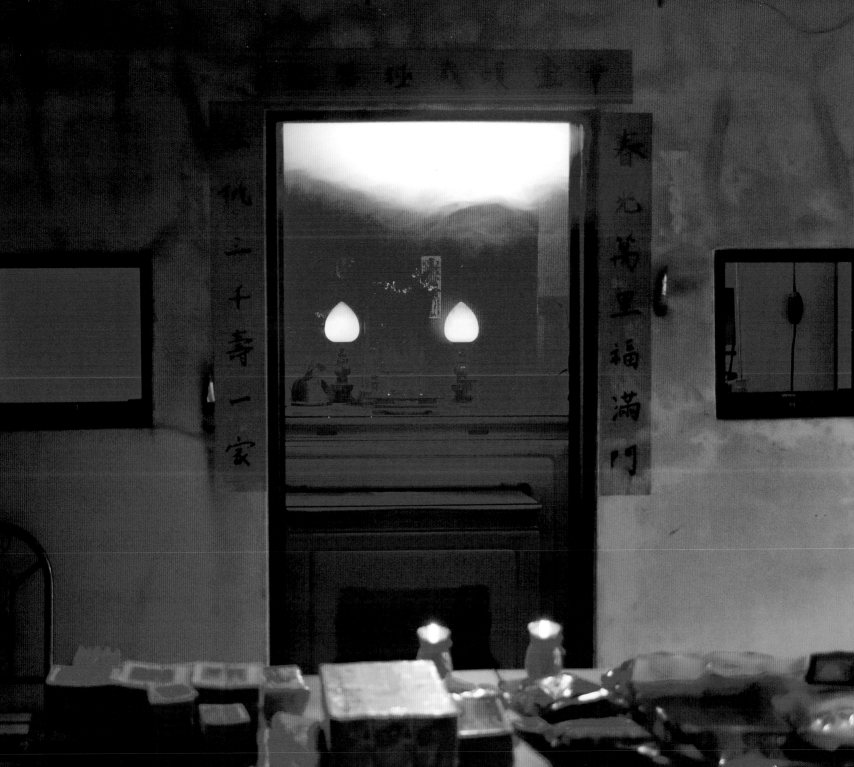

剷除老大

搶地盤代表除掉一個老大。拍攝場地是在發生過幾樁自殺案的某大樓屋頂，因此設有小廟。劇組奉上供品祭拜「好兄弟」。

Execution of a Leader

Taking over a territory means killing a leader.
These scenes are shot on a rooftop of a building in which there have been several suicides. For this reason there is a small temple on the roof. The offerings on the table in front of the shrine come from the film crew to keep any bad spirits at ease.

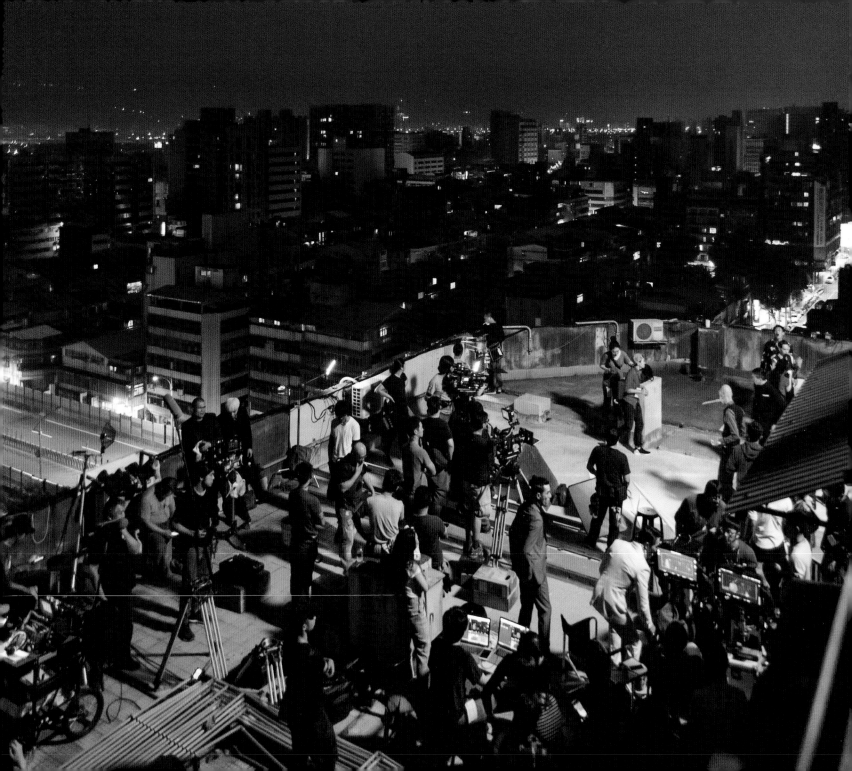

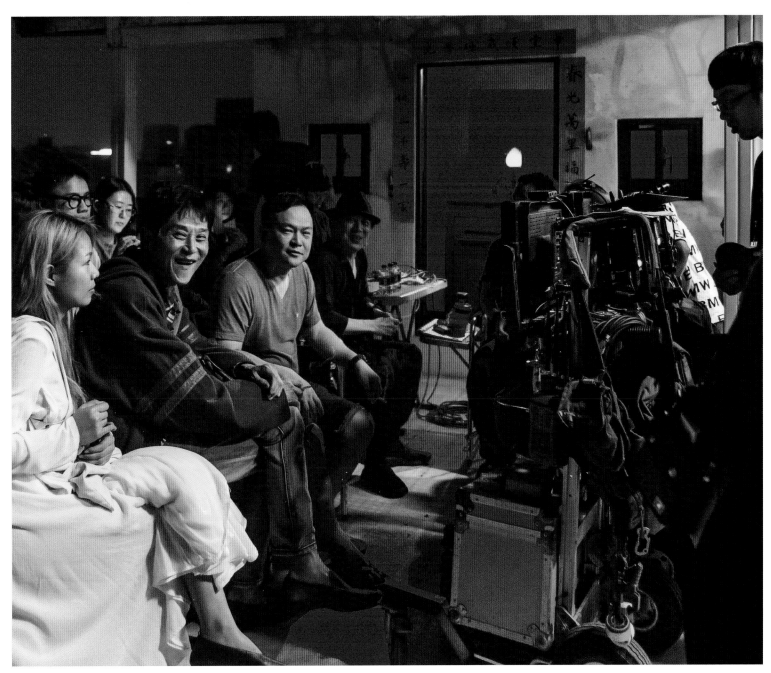

左：屋頂；上：張威縯與朋友們、導演組及演員
Left: The rooftop; Above: Mr. Red Chang with friends, directing crew and actor

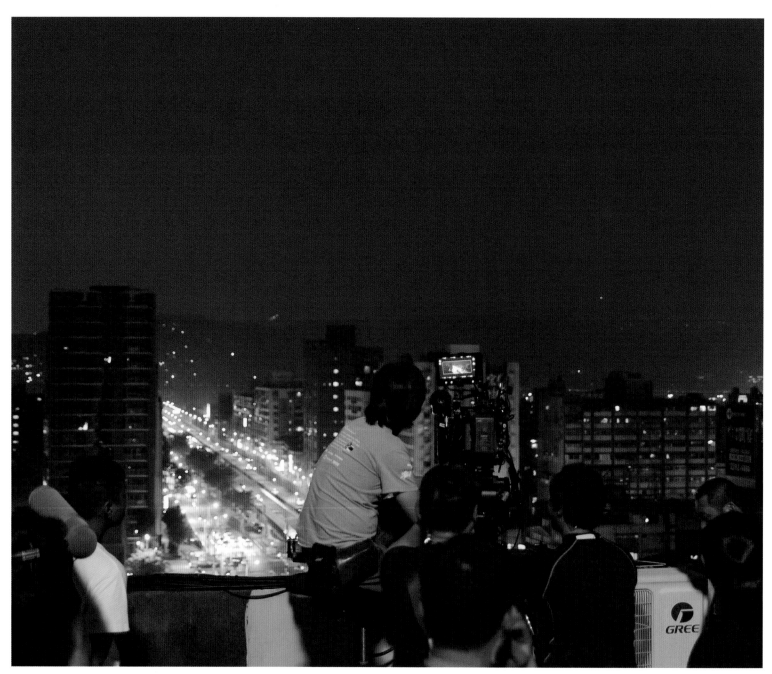

上與右：屋頂
Above and right: Rooftop

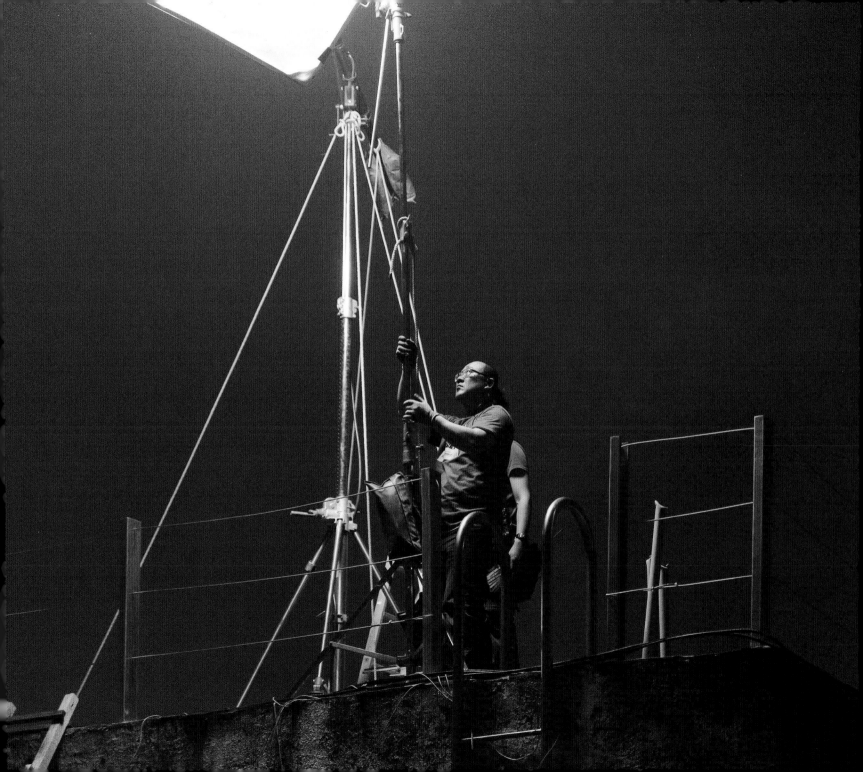

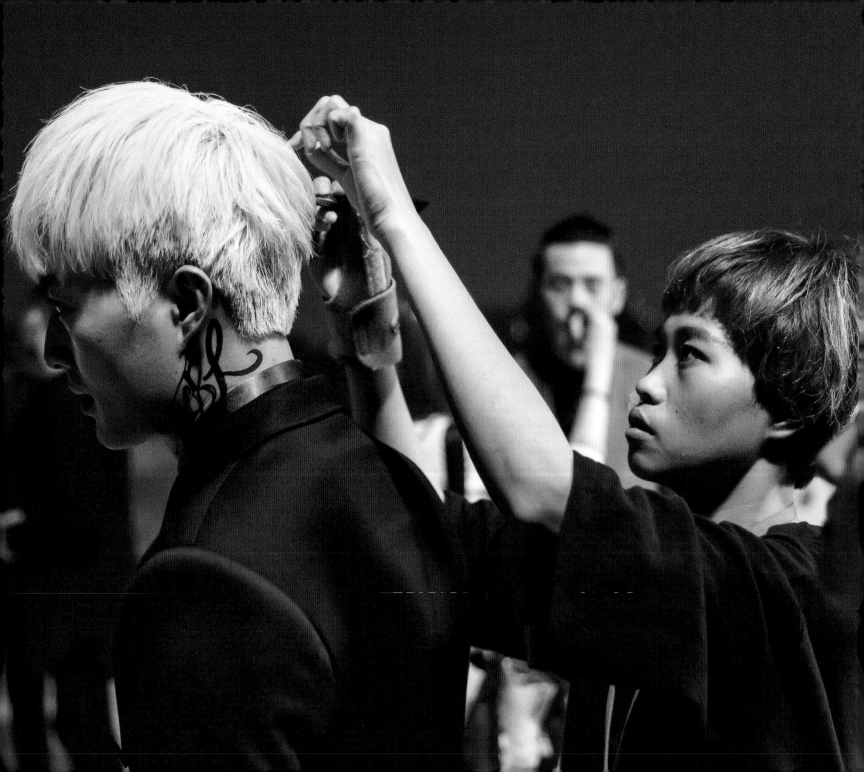

左：演員裝扮中；上：演員納涼中
Left: Actor getting styled; Above: Actor getting chilled

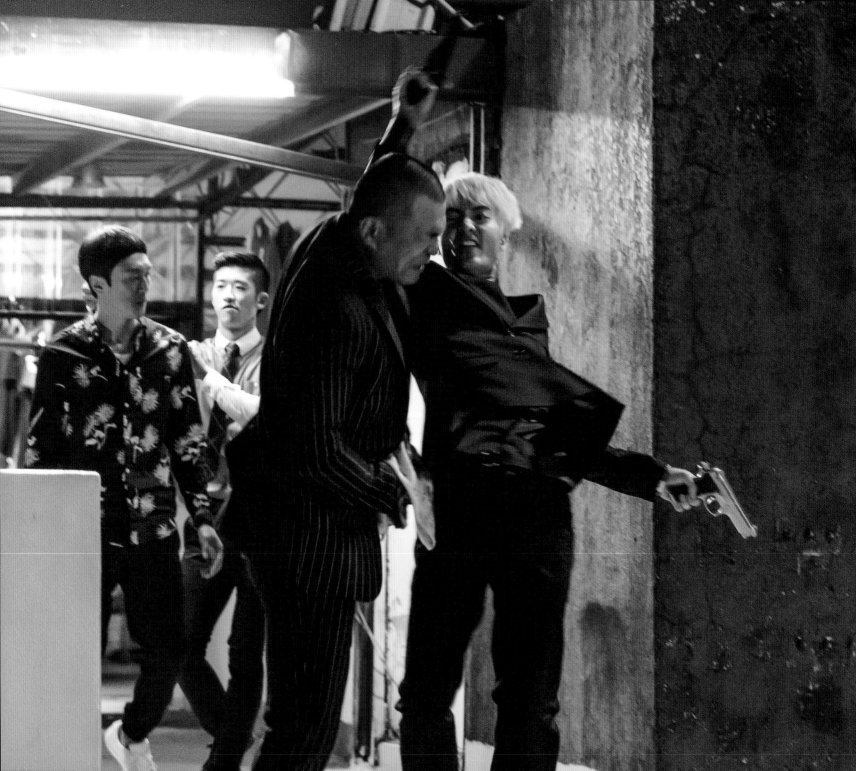

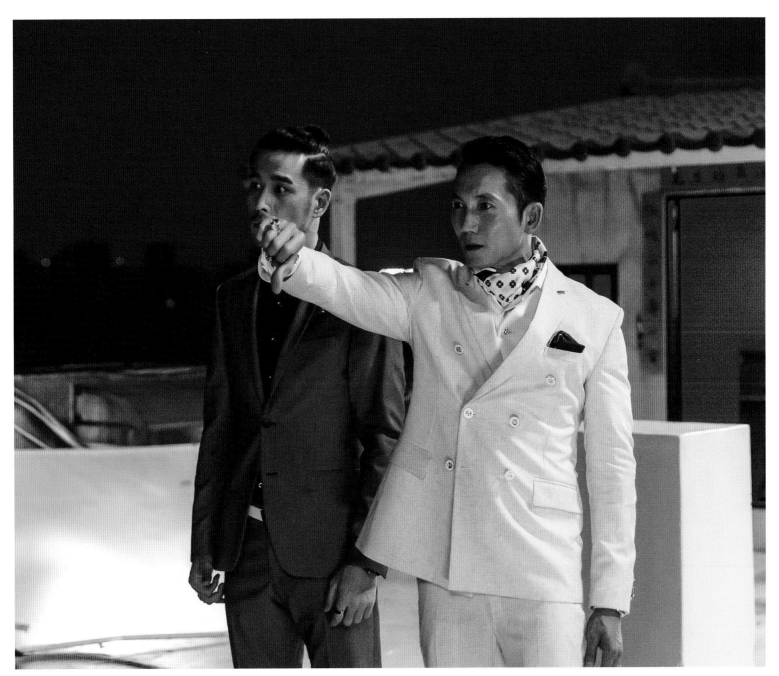

左：審判一名老大；上：判決
Left: A leader brought in to be judged; Above: The verdict

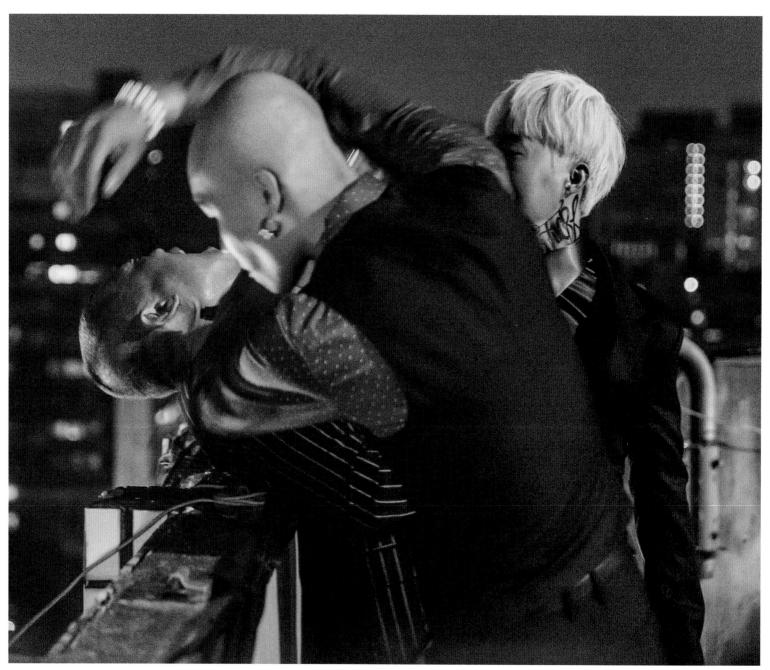

墜樓的前與後
Before and after free fall from the rooftop

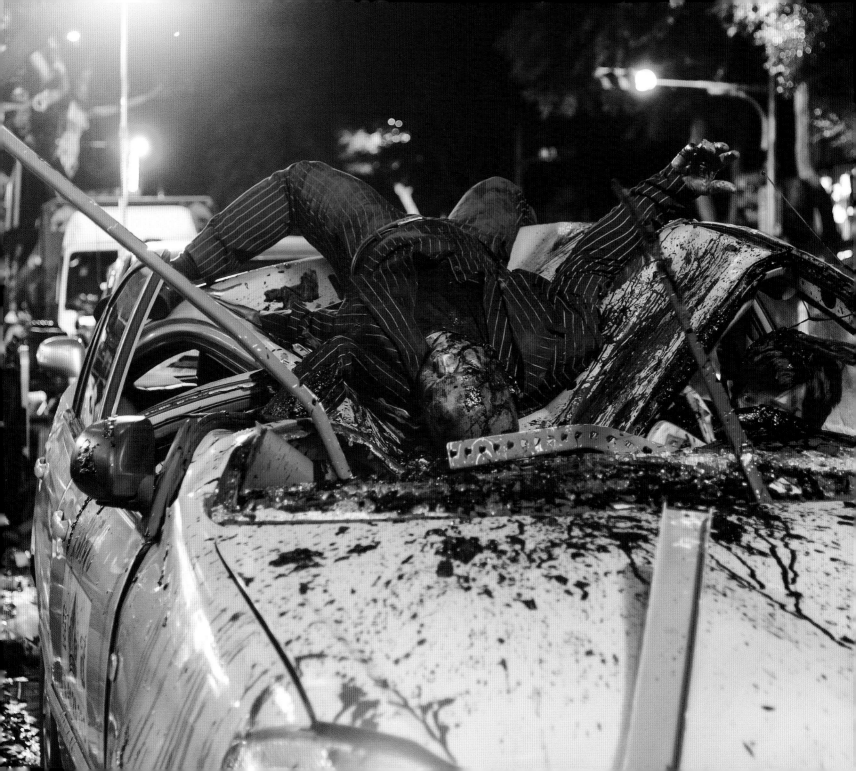

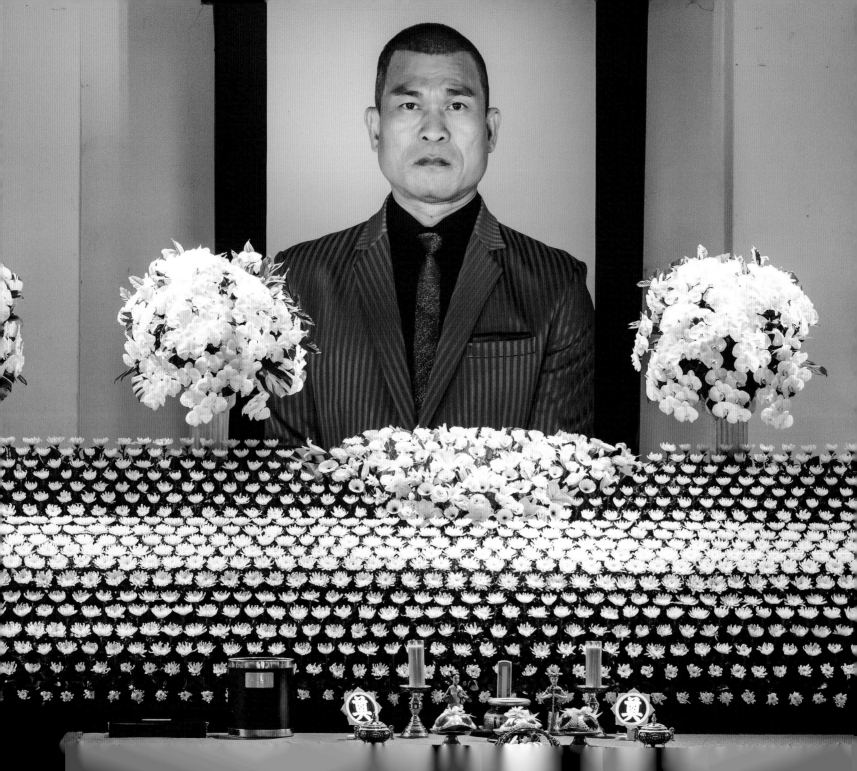

喪禮

江湖與角頭人生中極重要的一部分。公祭時,其他幫派老大皆率兄弟出席,展現勢力。勢力版圖缺了口,各路爭相弔奠、示威;喪禮充斥著挑釁和嘲諷,不會有打鬥。過去台灣老大的喪禮曾吸引大批日、港、泰、廈門、大馬1～2萬名兄弟到場。

Funerals

Funerals form a very important part in the life of triads and gatao. When an important leader has died other gangs and their
leaders come. You come to show your power. There is a hole in the power structure and everybody will come and pay respect and show his power. There is no fighting at a funeral, but there can be a lot of teasing and stirring of unrest.
Former funerals of Taiwanese triad leaders have attracted a lot of visitors from the triads of Japan, Hong Kong, Macau, Malaysia
and Thailand, 10,000 to 20,000 visitors.

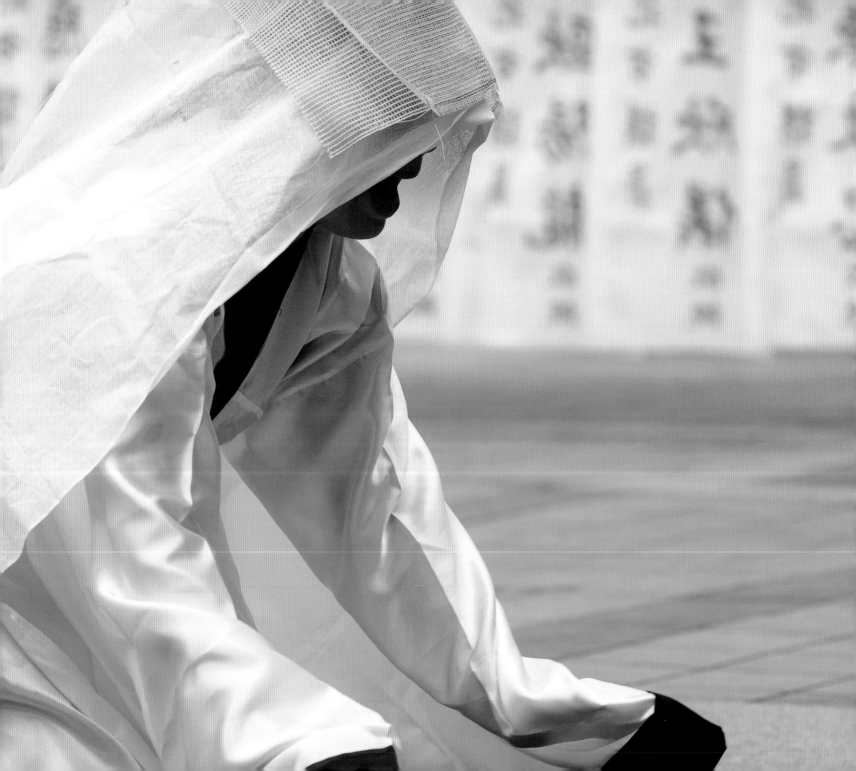

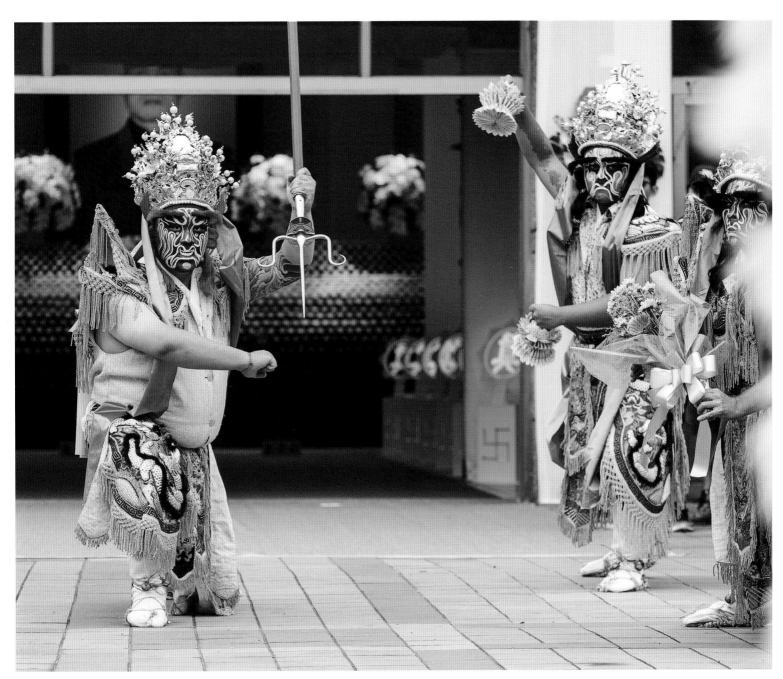

左：雇用的哭喪女；上：牽亡歌陣
Left: Crying woman hired for the funeral; Above: Gate keepers for where the soul will be going

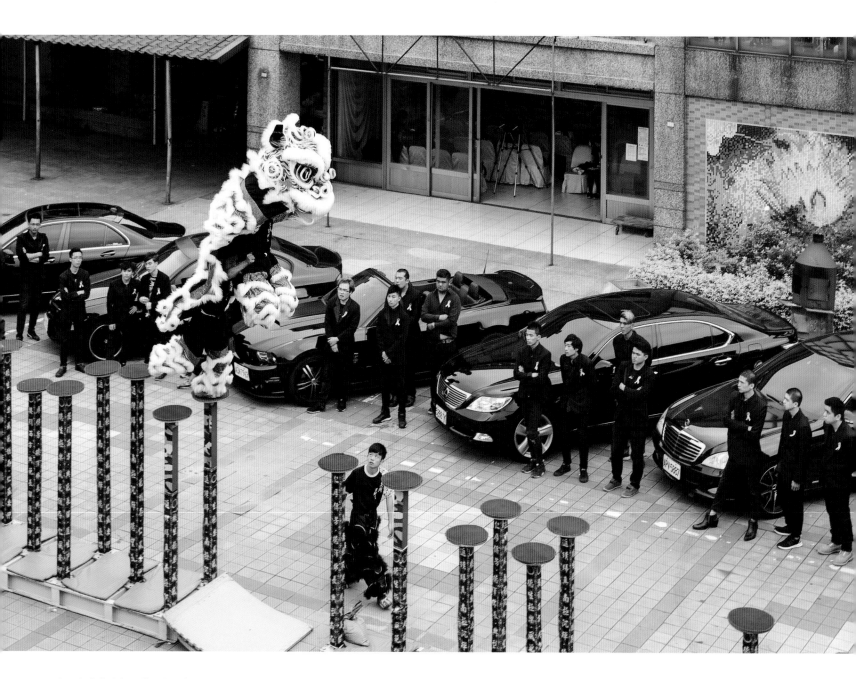

上：舞獅者與角頭弟兄真人演出；右：牽亡陣頭真人演出
Above: Lion dancers and gatao boys playing themselves; Right: Gate keeper playing himself

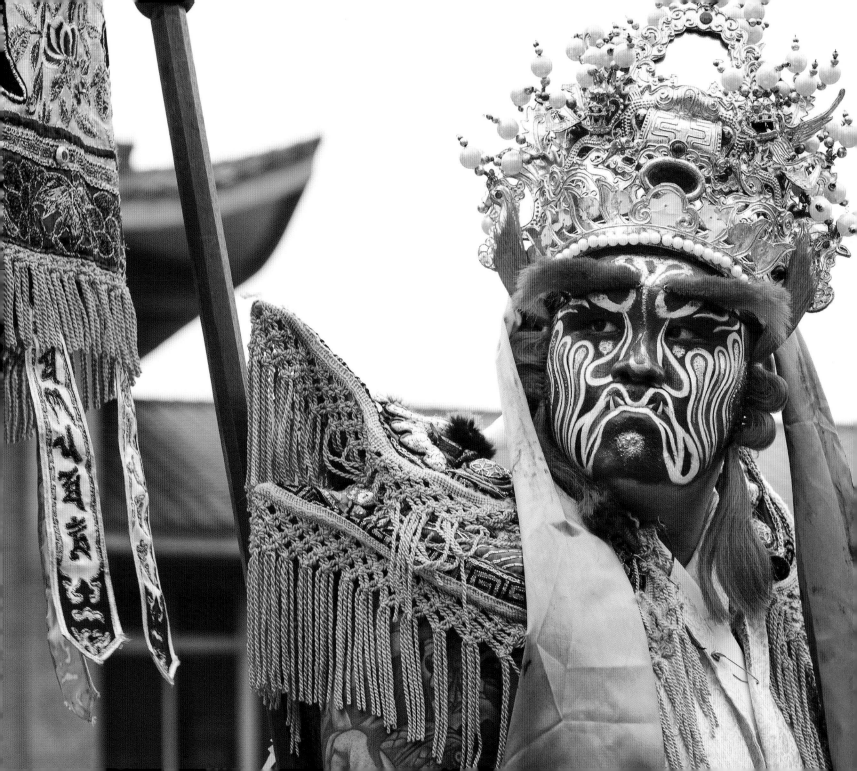

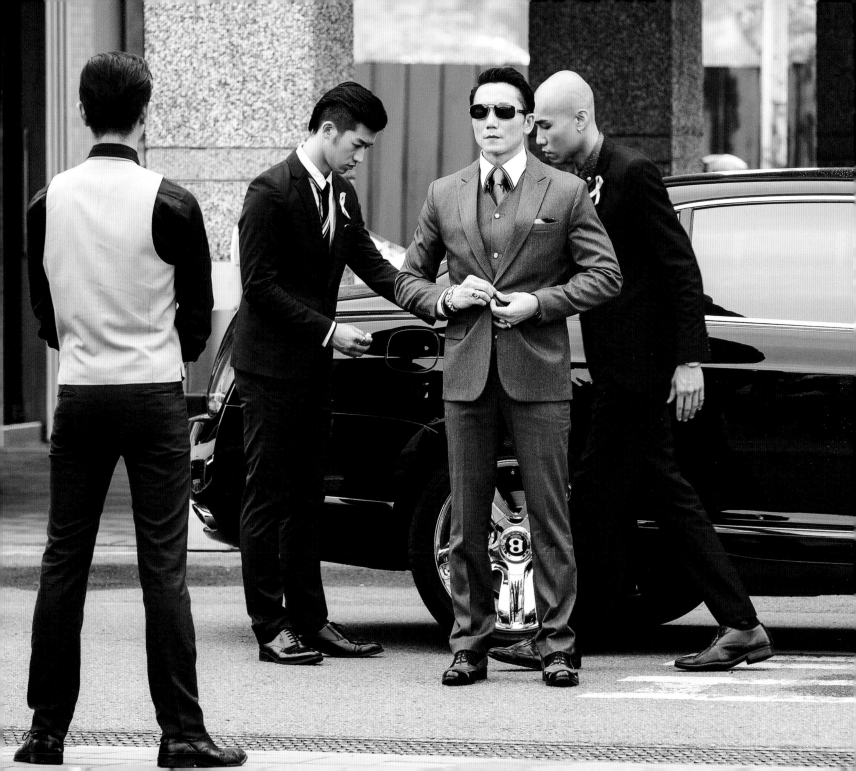

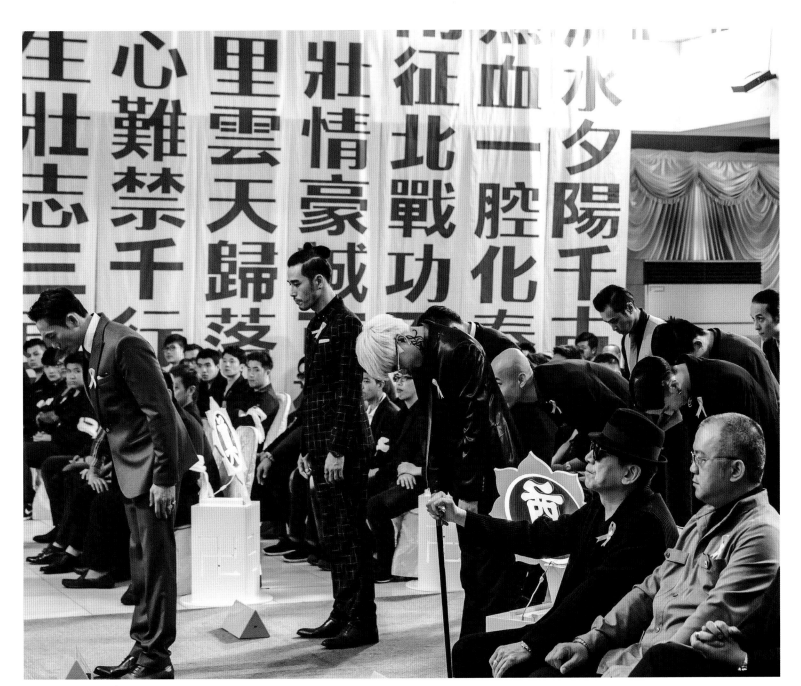

左：健合會老大（鄒兆龍）抵達喪禮；上：弔奠
Left: The executing leader, Collin Chou, arriving at the funeral; Above: Paying respect

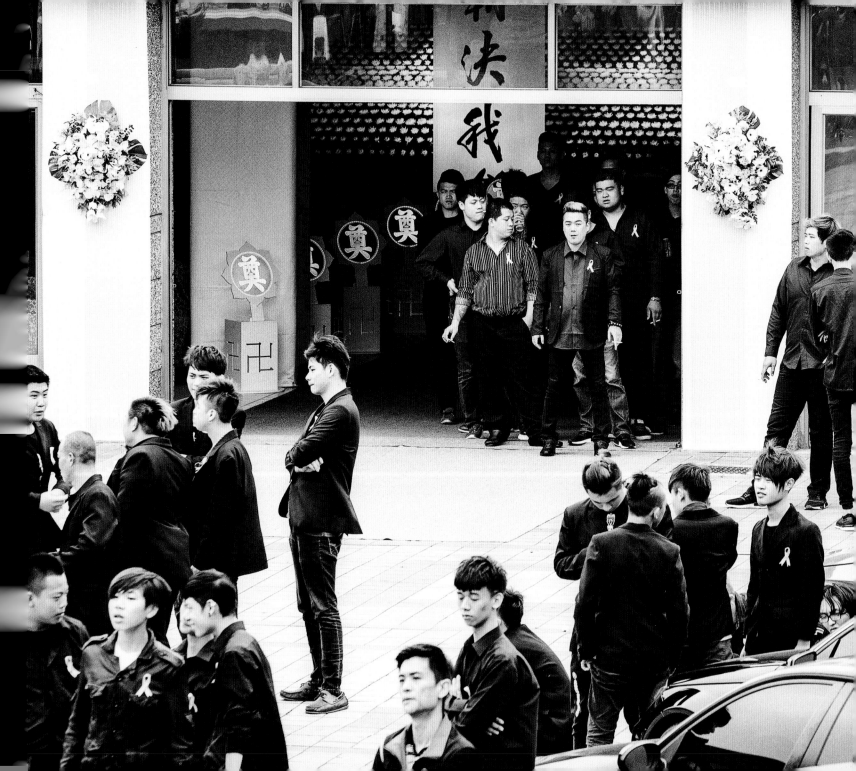

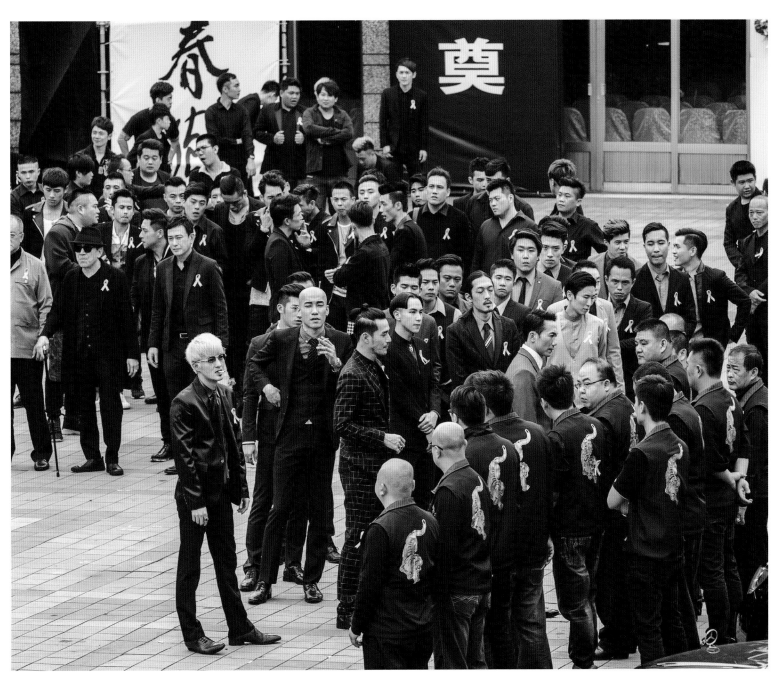

左：角頭兄弟真人演出；右：演員和角頭兄弟
Left: Gatao boys playing themselves; Right: Actors and gatao boys

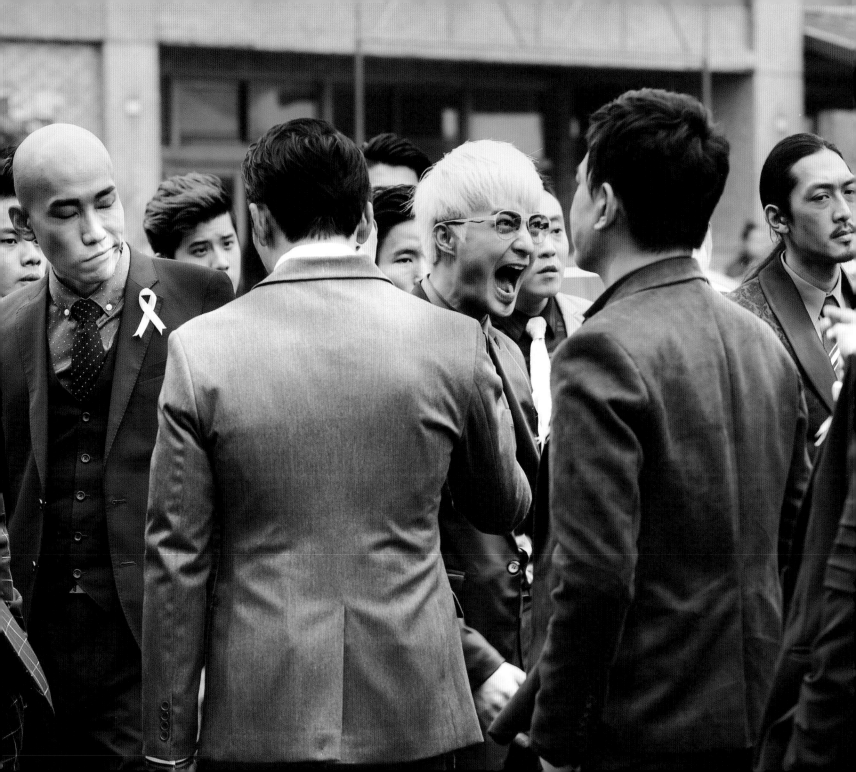

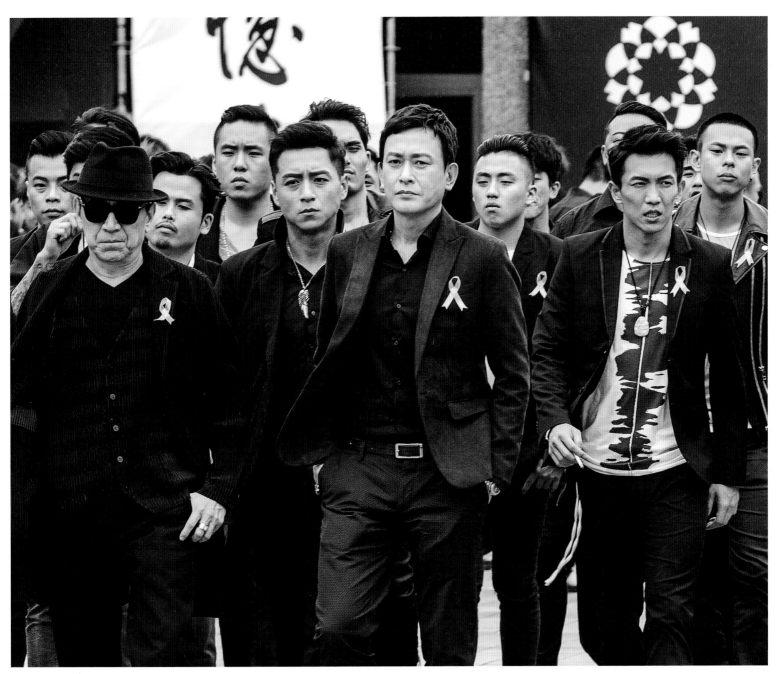

左：演員在喪禮上惹事；上：公祭完畢，演員帶頭與真人演出的角頭兄弟離場
Left: Actors stirring up at the funeral; Above: Time to leave, Actors followed by gatao boys playing themselves

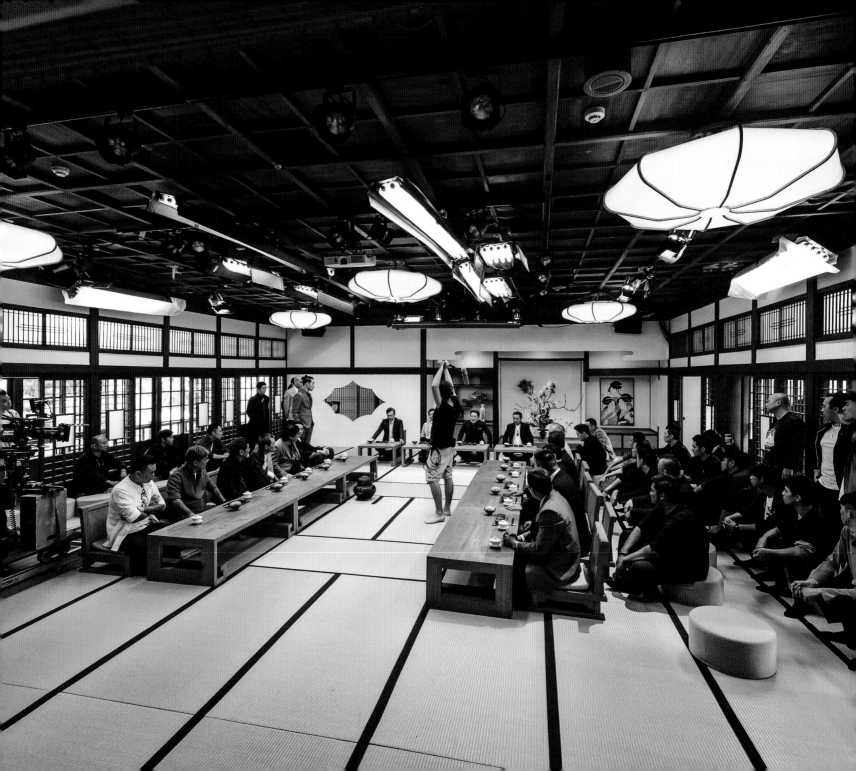

老大談判

和解及共享市場比爭鬥好，但總有例外，如電影中對事業的爭議 — 並非老大都愛毒品。

Meeting of Leaders

Settling disputes peacefully and sharing markets is always better than fighting, but it does not always work. Disagreements on business activity can also be a problem. In this movie - as in real life - some want to sell drugs, and some do not.

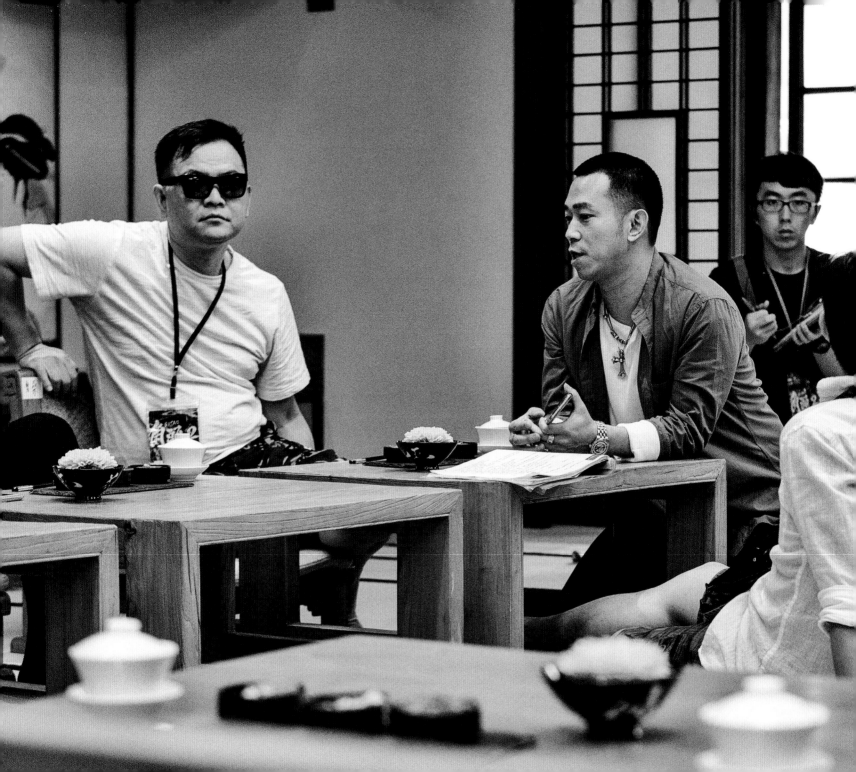

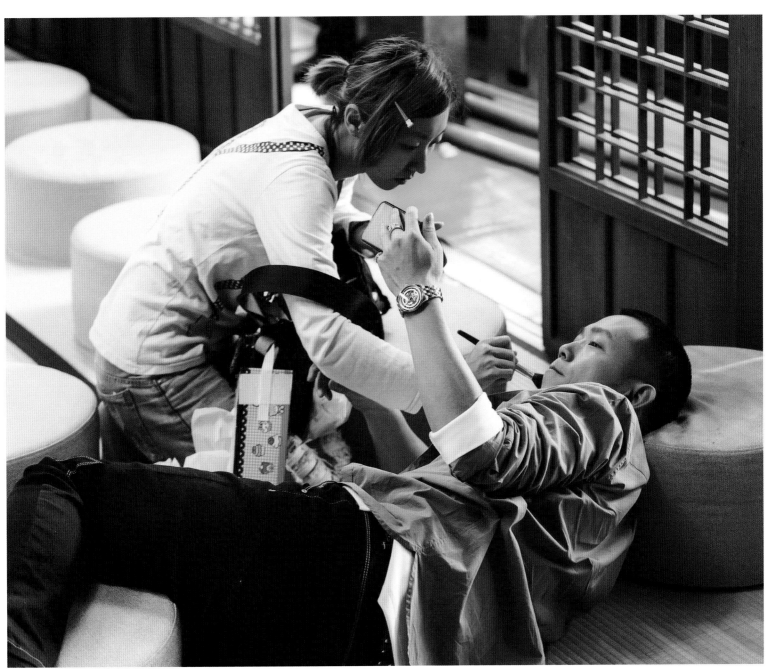

左：張威繽與導演討論談判的戲；右：導演假寐後上妝
Left: Mr. Red Chang and the Director talking about the meeting scene; Right: Director receiving some make up after a short nap

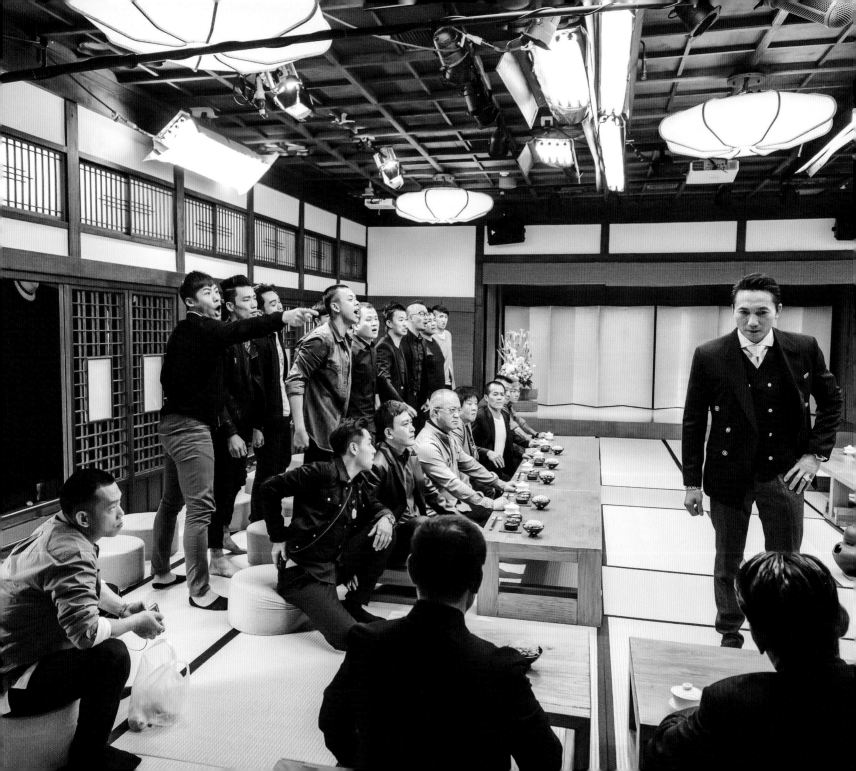

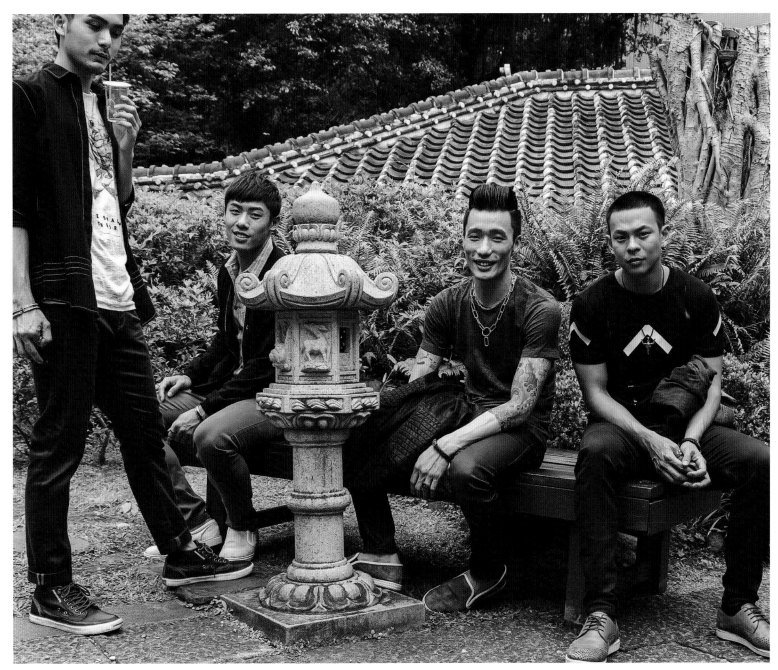

左：房間的一側；上：演員於室外休息
Left: One side of the room; Above: Actors relaxing outside

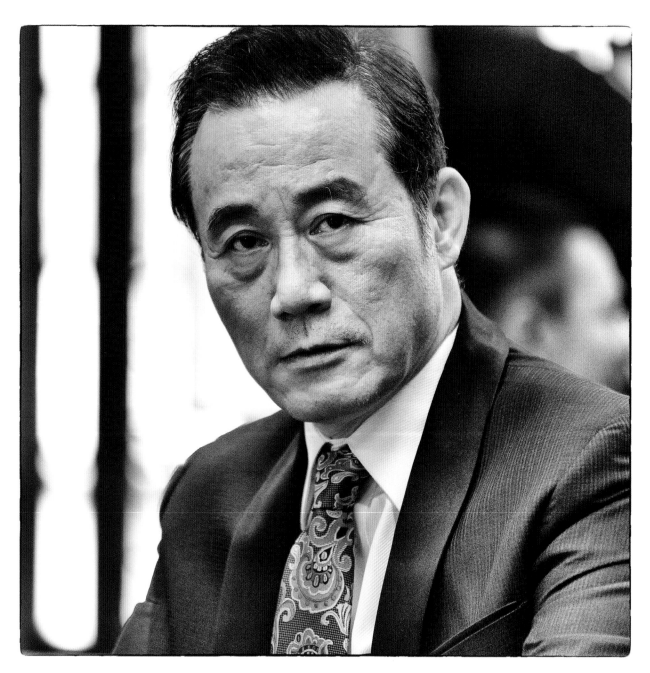

上：演員飾演老大；右：由演員和導演上陣，角頭老大坐於前方
Above: Leader played by actor; Right: Gatao main leaders at the head of the table, played by actors and director

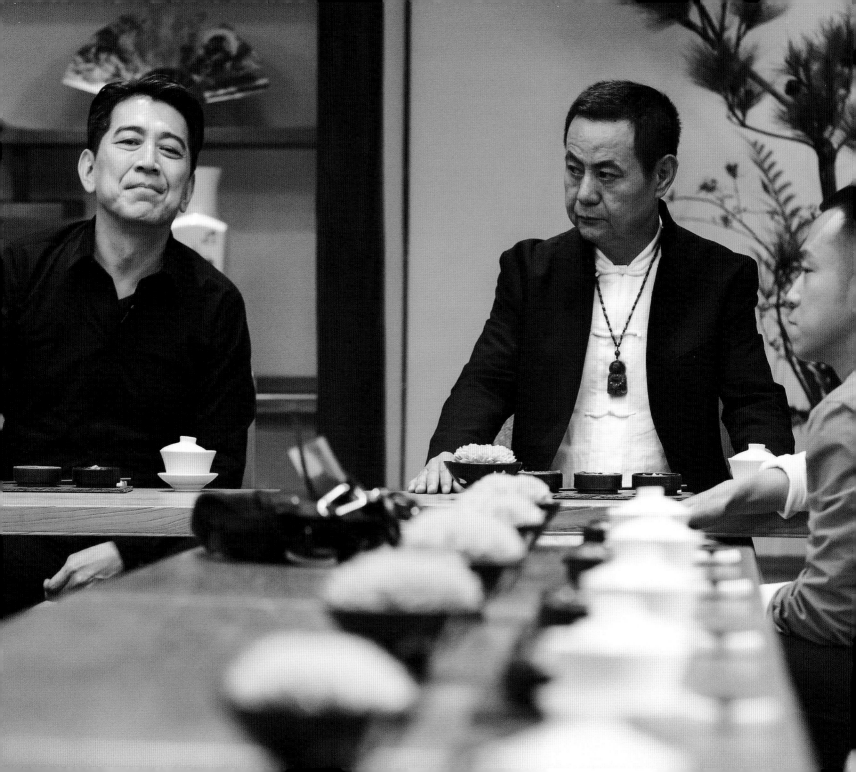

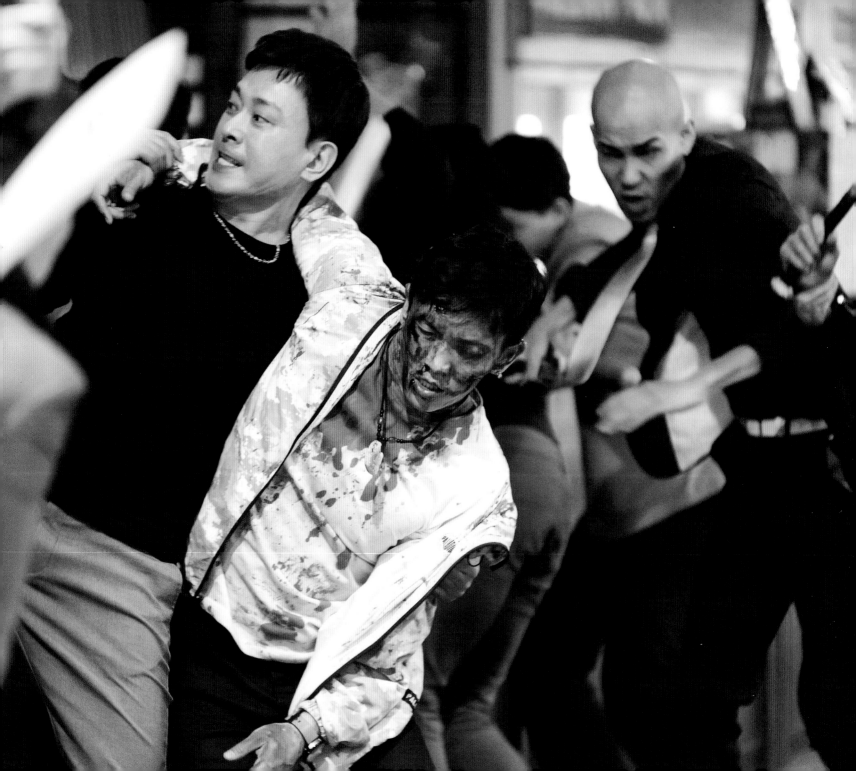

若不接受，就擊中你的要害。

仁哥的手下受到販毒錢潮的吸引而與劉健見面，這成了北館的弱點，仁哥毫不知情。劉健提出交易，仁哥拒絕合作販毒，劉健以殺掉北館的叛徒作為報復和強烈警告。最終搶救仁哥手下失敗。

If you do not take the offer, I will hurt you where you have a weakness.

Jian made Ren an offer. Ren's brother had already been attracted to the fast money from Jian's drug business and had met with Jian. Ren does not know this about his brother, and this is a weakness in his organization.
As Ren refuses to cooperate and share power with Jian in drugs, Jian pays him back by killing his disloyal brother. A strong statement. The attempt to save the brother is not successful.

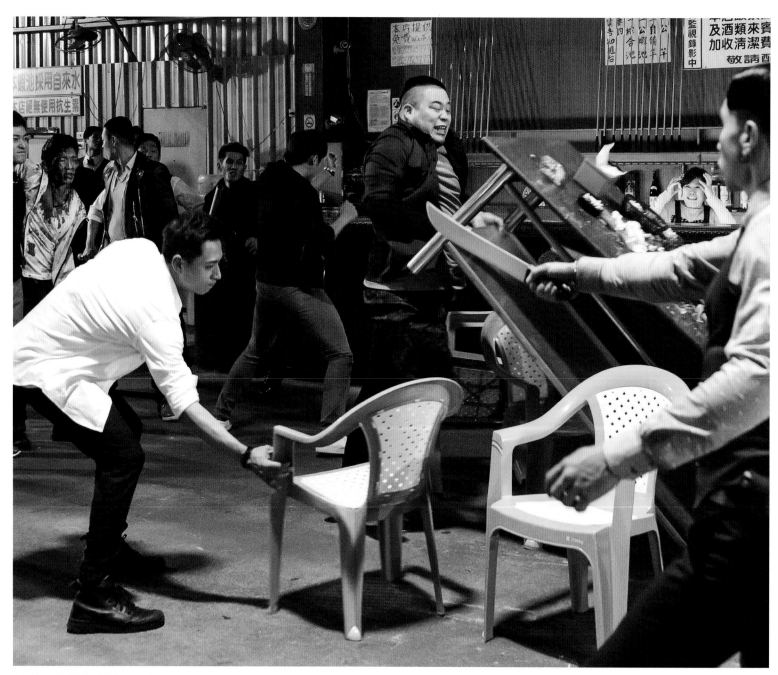

上與右：仁哥的兄弟們試圖救人
Above and Right: Ren's boys trying to rescue Ren's brother

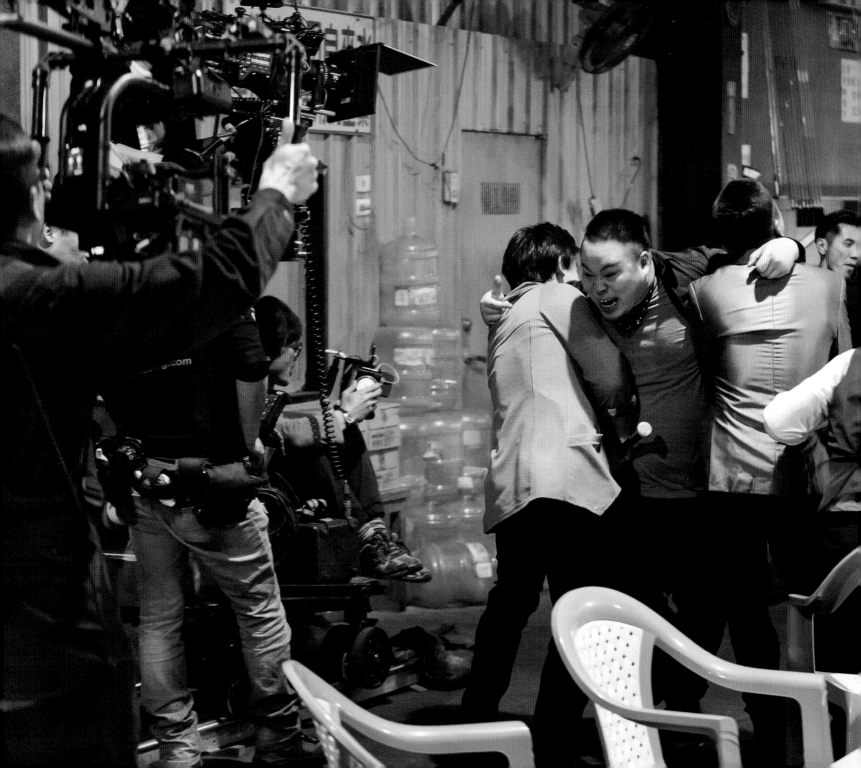

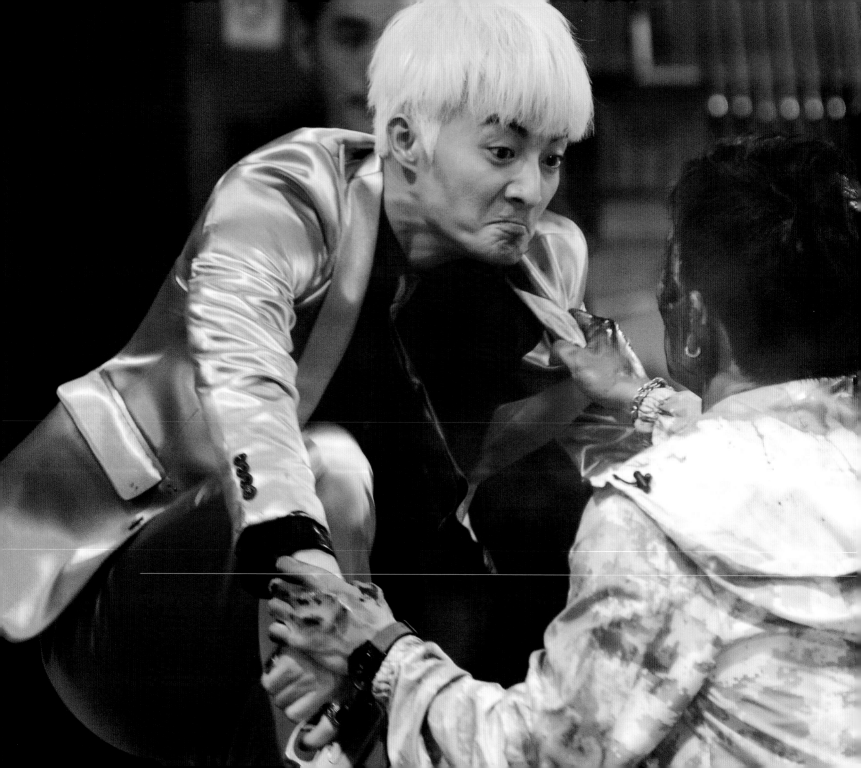

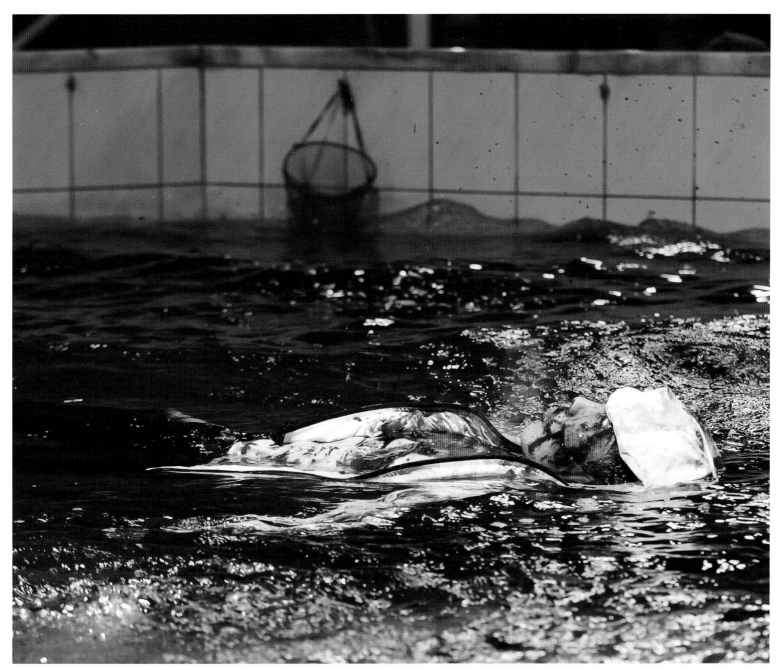

左與上：仁哥的手下被殺
Left and Above: Ren's brother is killed

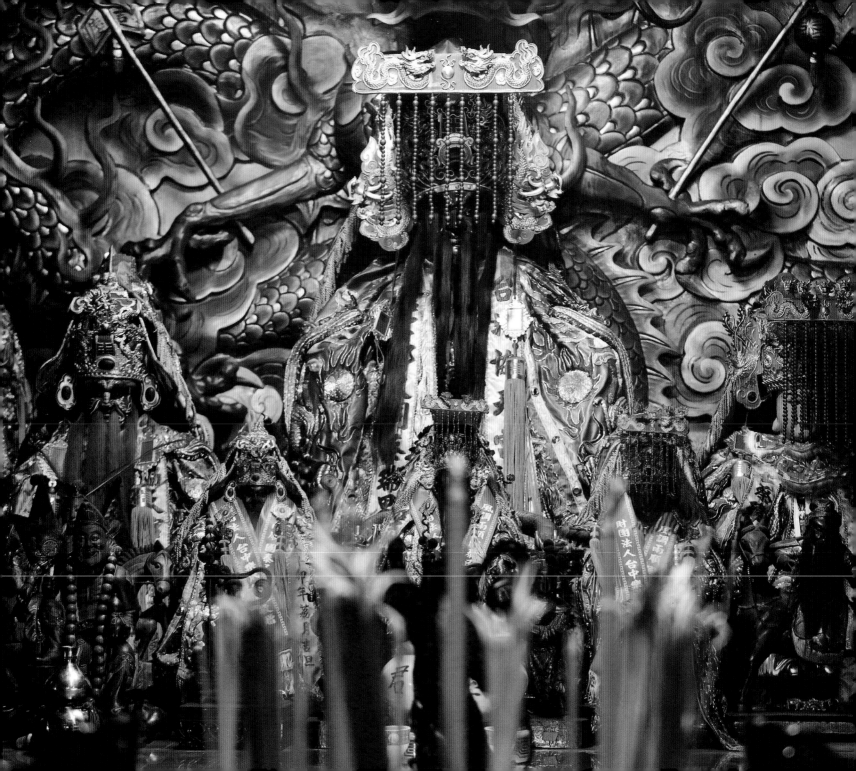

寺廟

寺廟像角頭的警察局，它熟悉整個地盤。寺廟也代表不同的神明，角頭到關公廟拜拜祈福，因為祂象徵功夫和道義。這場戲中，拜請關公選一名兄弟執行重要的復仇，一個非生則死的任務，抽到「生死籤」的就是關公指派的人。

Temples

Temples are like police stations for Gatao. The temple knows the neighborhood. But temples also represents different gods and when gatao use the temple for worship and spiritual support they choose the God Guan Gong.
He stands for Kung Fu and loyalty.
In these scenes they have come to let the God select one of them for the very important mission to revenge the brother. A mission of life and death, because you might die carrying it out. Drawing of the stick has the name "Sign of life and death."
The will of God points out the person to do the job.

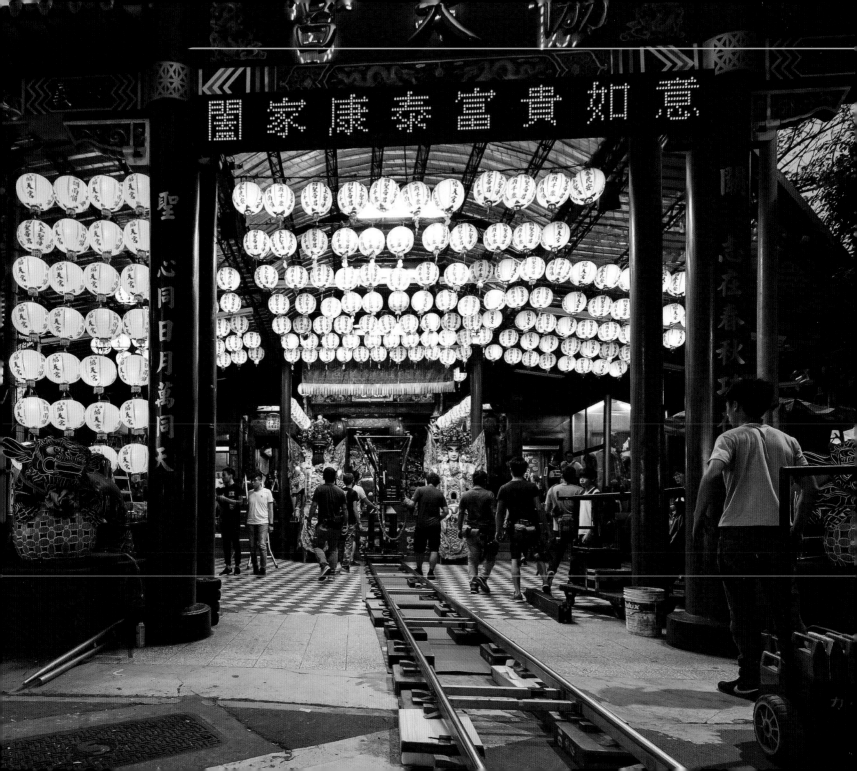

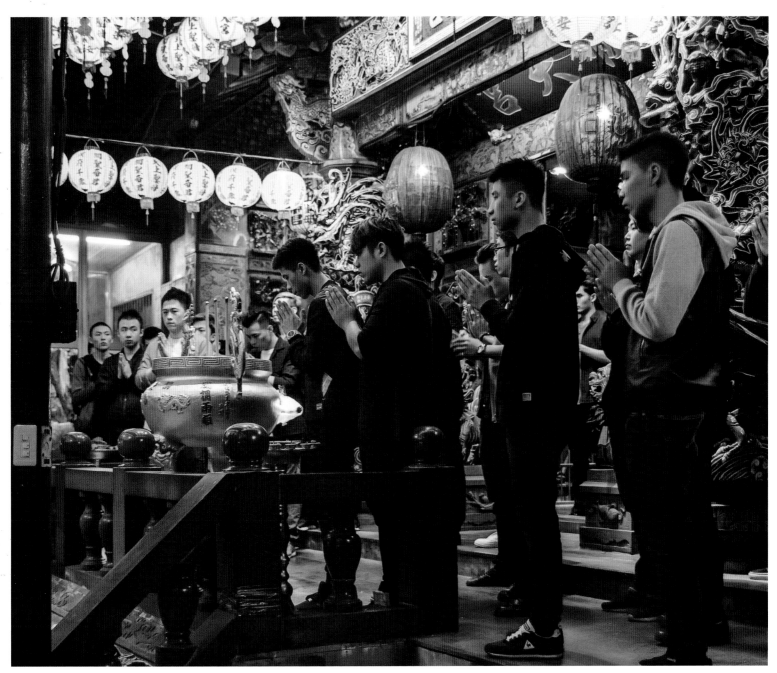

左：攝影和燈光組佈置中；上：角頭兄弟真人演出
Left: Camera and lighting crew setting up ; Above: Gatao boys playing themselves

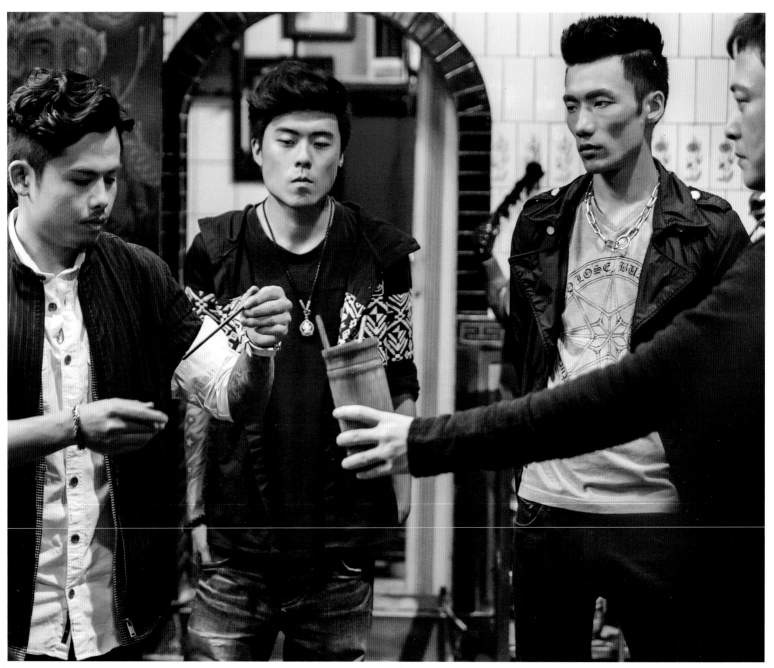

上：抽籤；右：祈求任務成功；下一跨頁：演員及攝影組在一起抽菸
Above: Drawing of the stick; Right: Asking for blessing in carrying out the job; Next spread: Actor and camera crew smoking together

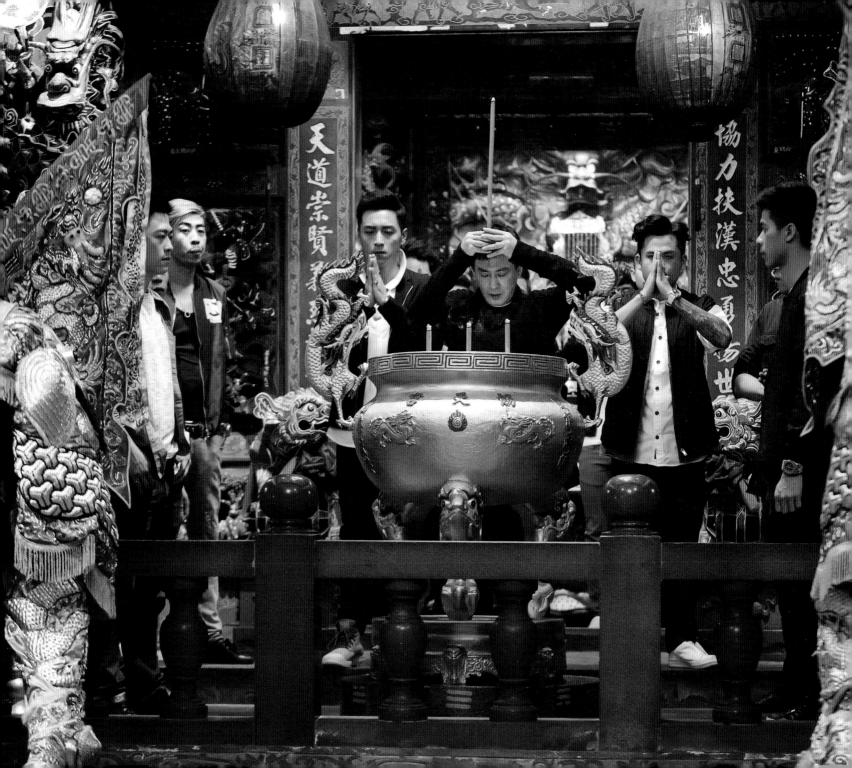

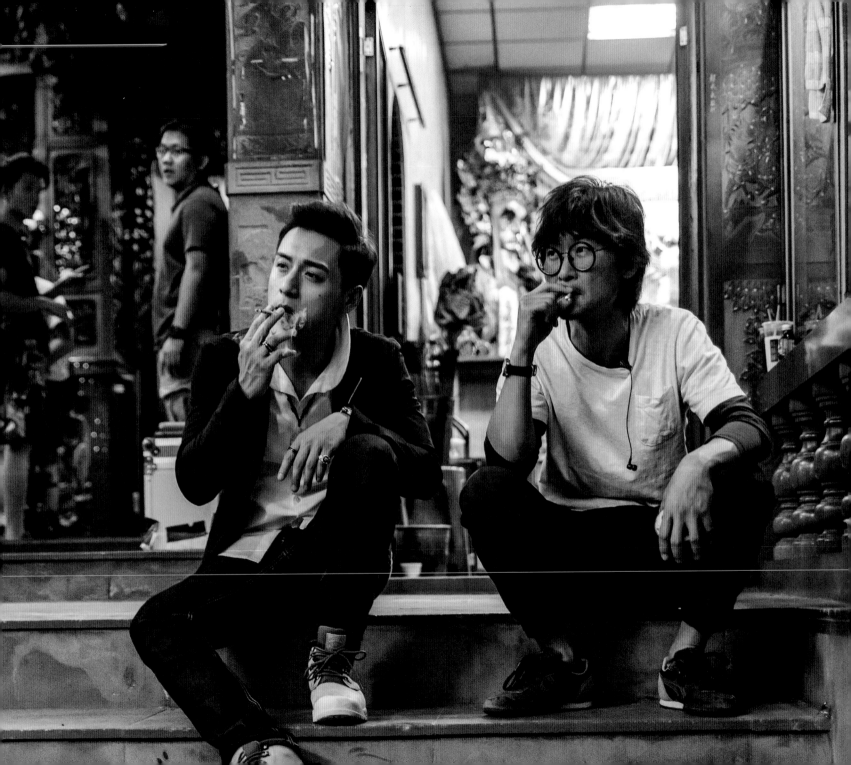

結束 - THE END

領銜主演 / Starring Actors

劉健	鄒兆龍
Jian Liu	Collin Chou
仁哥	王識賢
Ren	Shih Hsien Wang

特別演出 / Special Appearances

貴董	高捷
President Gui	Jack Kao
勇男	蔡振南
Yung	Tsai, Chen-Nan
阿超嬤	呂雪鳳
Chao's Grandmother	Lu, Hsueh-Feng
清楓	孫鵬
Fung	Edward Sun
C哥	邵昕
Big-C	Xao xin
貴嫂	狄鶯
President Gui's Wife	Lin, Chia-Hsuan

主要演員 / Co-starring

阿慶	鄭人碩	憨春	陳萬號
Qing	Cheng, Jen-Shuo	Simple-Chun	Chen, Meng-Ting
阿超	黃尚禾	Diablo	孫國豪
Chao	Shang Ho, Huang	Diablo	Richard
潘帥	唐振剛	仁嫂	曾珮瑜
Pretty-Pan	Gary Tang	Ren's Wife	Peggy Tseng
宗保	張再興	唐玲	許維恩
Po	Zhang-Xing Chang	Ren's Mistress	Sharon Hus
胖達	吳震亞	宣宣	王宣
Panda	Panda Wu	Pretty-Pan's Fiancée	Angel Wang
阿標	黃騰浩	羅叔	朱進新 / 朱九
Biao	Tender Huang	Lou	Chu Chin Hsin
壞壞	古斌	阿虎	張鐵齒
Syko	Samuel K	Simple-Chun's Brother	Iron teeth
高副	樓學賢	美娜	林真亦
Government Agent	Lou, Hsuek-Hsienk	Maina	Yuna Lin
分局長	尹昭德		
Mr. Secretary	Yin, Jau-Der		
C哥小弟	嘎嘎	李洛洋	周定緯
Big-C's assistant	Chris pan	Lil Young	Judy Chou
北城	JV 陳政文	張曦帆	
The North Town	Edison JV	Conjee Chang	
北館	林煜翔	孫綻	涂力榮
The North Fort	George Lin	Sean	Li Rong Tu
	李權修	林世融	王志演
	Lee Chuan Hsiu	Longa	Chih-Yen Wang
	邱柏諺 / 猴子	謝宜竣	盧證宇
	Po-Yen CHIU	Hsieh, Yi-Chun	Lu Zhengyu
	劉楷文	嚴書凱	高仲逵
	Liu, Kai-Wen	Yan Shu Kai	GAO, JHONG-KUEI
	林睿紳	林昱瑋	徐品豪
	Kin Run Shen	Chen Yu Wei	Xu Pin Hao
	洪正韋		
	Hung, Cheng-Wei		
健合會	林道禹	洪聆翔	李至元
Jian Corp.	Oscar Lin	Sean Hung	Li Zhi Yuan
	牛仁博 / 十三	翁翔淵 / 千翔	王義欽 / 修羅
	XIII	K. Sean	Soulja
	許近思 / 鐵夫	姬禹丞 / 姬	言奕辰
	Dave Hsu	Ivan Ji	Eason
	賴昱宏	應家琛	陳奕禎
	Lai Yu Hung	Jia Chen Ying	CYC
	王偉恩		
	Wayne Wang		

涂家瑋　　　　　陳漢蔚　　　　　　許應世　　　　　陳文宗
陳英宇　　　　　鍾坤峰　　　　　　郭守敬　　　　　洪連辰
盧冠允　　　　　廖延翰　　　　　　卓宏立　　　　　陳俊偉

<div align="center">演出名單 / EXTRAS</div>

裴頡	李嘉寓	周毅銓	李家儀
楊庭欣	周侑霖	張志杰	趙意君
張家偉	林靜怡	楊凱丞	許洺菀
黃舒鈺	郝翊展	張忠瑞	陳紹文
柯仲達	張桓輔	林哲豪	林志龍
秦俞軒	黃建智	藍小傑	陳則維
賴燊	傑瑞哥	林奕良	蒙亮憶
吳睿陽	黃小雯	劉宜群	林聖彰
高添發	翁偉峻	唐沛羚	陳加倚
陳昱瑋	王竣民	王博賢	簡俊傑
陳思蓉	林進龍	陳玉青	高定緯
陳采捷	黃信傑	趙子賢	鍾素儀
徐品豪	陳旻新	阮怡盈	張玉南
黃勝柏	張徑豪	敖采渝	林右君
李尉縈	康健祥	方源	張覺引
李家葳	林家瑩	潘芃瑜	吳昱瑩
高玉玲	林志泓	黃千宇	陳琬琪
林旭元	陳杰均	王志豪	林佳葦
林怡廷	彭裕翔	柯淑娟	蔡宜家
李開煜	王碩瀚	詹翔勝	王剛
徐慧安	林奕旗	陳松濤	高小利
殷稜雅	謝秋月	彭睿翔	王政琨
林岱蓁	林義欽	石聖龍	林芯樂
陳俊嘉	蔡璨宇	涂家瑋	王子誼
陳俊維	邊偉豪	張啟文	陳瑋瑋
陳添福	信維宗	侯宗華	陳宇馨
吳品呈	吳澤煒	黃國欽	馮詩涵
葉宗潤	王騰毅	許銘仁	施語庭
鄭振富	商鈞	姜智航	邵俐妍
謝曉瑋	鄭宇辰	儲佑軒	邱雅翎
黃耀霆	楊尚融	林賢泓	呂秋賢
曾建智	廖梅	陳春興	彭美玲
林于勝	張國和	付勇超	王春勇
王朝陽	趙四如	董芬華	徐三歲

出品公司 Present	理大國際多媒體股份有限公司 LE DAY MULTIMEDIA CO., LTD.		
出品人 Presented by	張威繽 Red Chang	張文旗 Simon Chang	
監製 / 製片人 Executive Producer	張威繽 Red Chang		
製作公司 Production	理大國際多媒體股份有限公司 LE DAY MULTIMEDIA CO., LTD.		
聯合出品 In Association with	柏合麗國際影業股份有限公司 Polyface Entertainment Media Co., Ltd.	能海電能科技股份有限公司 Energy Moana Technology CO., LTD.	路得寶交通股份有限公司 Roadpro CO., LTD.
	鑫盛傳媒製作股份有限公司 KINGSHINE ENTERTAINMENT,INC.	鐵人文創娛樂有限公司 T-LANG CULTURAL & CREATIVE ENTERTAINMENT CO.LTD.	華人電通文化傳媒有限公司 HUA REN ENTERTAINMENT CO.
	捷泰精密工業股份有限公司 JYE TAI PRECISION INDUSTRIAL. CO., LTD.	昇華娛樂傳播股份有限公司 SHENGHUA ENTERTAINMENT COMMUNICATION CO.,LTD.	

導演 Director	顏正國 Yen,Cheng Kuo	執行導演 Executive Director	姜瑞智 Ray Jiang
第一副導演 1st Assistant Director	李為濂 Wei-Lien Lee	第二副導演 2nd Assistant Director	吳瑪涵 Seven-Up Wu
助理導演 Assistant to Director	劉佩宜 Summer Liu	助理導演 Assistant to Director	張志杰 Mojo Chang
場記 Script Supervisor	余岱旂 Davis Yu		
編劇 Screenplay Writers	張威縝 Red Chang		孫法鈞 Jerry Sun
戲劇老師 Performing Director	黃浩詠 Huang Hao Yung	導演組實習生 Director Interns	楊凱丞 Kai Cheng Yang
製作統籌 Production Supervisor	李若凱 Karen Lee	製作協調 Production Coordinator	林小肯 Ken Lin
製片 Production supervisor	周毅銓 Sarso Chou	外聯製片 Unit Production Manager	張一德 Ito Chang
珠海外聯 Jnit Production Manager	鐘春田 Zhong, Chun Tian	執行製片 Associate Producer	郝翊展 Hao Yi Zhan
生活製片 Craft Service	李家儀 Ding Li	動作協調 Production Assistant	蔡孟勳 Meng-Hsun Tsai
車輛管理 Production Assistant	張家偉 Gawii Chang		
製片助理 Production Assistants	黃舒鈺 Shu-Yu,Huang	林宛欣 Lin Wan Shin	周侑霖 Yu Lin Chou
	李宗霖 Li, Tsung Lin		
場景助理 Jnit Production Assistants	楊庭欣 Atoo Yang	李姵靜 Li Pei Jing	洪雅治 Hung Ya Chih
製片組實習生 Production Interns	賴欣佳 Lai,Xin Jia	許洛菀 Hsu Ming-Wan	
攝影指導 Director of photography	姚宏易 Yao Hung-I	攝影大助 1st Assistant Cameraman	王冠勳 Wang Kuan-Hsun
攝影二助 2nd Assistant Cameramen	林哲佑 Lin, Che Yu	戴育祺 Tai, Yu Chi	
攝影三助 Camera Assistant	李方裕 Li, Fang Yu	二機攝影師 B Cameraman	李青澤 Li, Ching Tse
DIT	曾向怡 Tseng, Hsiang Yi	李典晉 Li, Tien Chin	
燈光指導 Lightening Director	李嘉寓 Li, Jia Yu	燈光大助 1st Best Boys	沈源 Shen,Yuan
燈光二助 2nd Best Boys	劉睿綱 Liu, Jui Kang		
燈光助理 Electricians	蕭鴻益 Hsiao-Hung-Yi	李易泰 Lee,Yi Tai	曾宥運 Tseng,You,Yun
	林建志 Lin,Jian-Jhih		
選角指導 Casting Supervisor	柯博仁 Ko.Po.Jen		
演員管理 Artist Assistants	高珮馨 Star Kao	李皓雯 Hao-Wen,Lee	林煜翔 George Lin
執行經紀 Artist Broker	許朝富 Morris Hui	演員組實習生 Casting Interns	趙意君 Chao,Yi-Chun
錄音指導 Boom Operator	湯湘竹 Tang Haiang Chu		
錄音助理 Assistant Boom Operators	吳建緯 Wu, Chien Wei	許巧函 Hsu, Chiao Han	

音樂製作
Music
動作導演(韓)
Martial Arts Director
動作指導(韓)
Action Choreographers
動作協力
Action Choreographer
韓文翻譯
Korean Translators
槍械提供
Armaments provided by
槍械指導
Weapon Advisor
槍械師
Armorers
爆破指導
Pyrotechnic
爆破助理
Assistant Pyrotechnics

JV 陳政文
Edison JV
洪義淳 홍의정
Hong Eui Jung
金承弼 김승필
Chin, Cheng Pi
吳震亞
Chen Ya,Wu
林家竹
Lin, Chia Chu
寶力道具有限公司(香港)
PROPS Co., Ltd.
陳偉民
Chen Wei-Ming
陳彥志
Chen Yan-Zhi
陳銘澤
Chen Mingze
曾韋菖
Tseng, Wei Chang
黃泰維
Teddy Ray Huang

電影配樂
Music Scoring

李光鎬 이광호
Li, Kuang Hao

崔旻秀
Tsui, Min Hsiu
威炫國際有限公司(台灣)
PRO-ACT Co., Ltd.

陳世杰
Chen Shih-Chieh

呂革進
Johnny Lu

黃綻默
Armo Huang

曾富田
Tien Tien

美術指導
Art Director
道具助理
Property Assistants
陳設執行
Set Props
陳設助理
Asst. Art Designers

姚國禎
Yao Kuo-Chen
丁芮萱
Ting Jui-Hsuan
莊凱淳
Jhuang Kai-Chun
陳冠霓
Chen Guan-Ni
吳敏綺
Wu Min-Chi
沈昌緯
Shen Chang-Wei
蔡嘉和
Tsai Chia-Han

道具師
Property Master
傅捷
Fu Jie
趙春茂
Chun Chao-Mao
林佩萱
Lin Pei-Syuan
沈安
Shen An

柯治旻
Ko Chih-Min

黃瀚正
Huang Han-Chang
陳琬琇
Chen Wan-Shiou
郭于綺
Guo Yu-Chi

現場執行
Propsman
現場助理
Set Dressers
平面設計
graphic designer
行政統籌
Administration Supervisor
美術組實習生
Art Department Interns
場務團隊
Production Assistant
美術場務
Art Set Coordinators

葉人豪
Yeh Jen-Hao
劉凱青
Liu Kai-Ching
鄧靜儀
Arden Teng
黃瑄
Huang Shiuan
效力社影像工作室
O.P.S.studio
蔡柏風
Benson Tsai
江裕禧
Louis Chiang

金子涵
Hannah Chin
氣氛圖
graphic designer

張瑋真
Chang Wei-Jen

范家斌
Oscar
林愛紋
Mango

林裕翔
Shawn Lin

余家寶
Jiabao

質感團隊
Scenic art
質感統籌
Scenic art supervisor
質感專員
Scenic artist

法蘭克質感創作有限公司
Frank Scenic Art Company
林彥儒
Lin Yen-Ju
林盈閑
Lin Ying-Xian
余蔡平
Yu Tsai-Ping

質感總監
Scenic art producer
質感執行
Executive scenic artist
賴儀恬
Lai Yi-Tian
林相如
Lin Hsiang-Ju

陳新發
Frank Chen
謝萬運
Xie Wan-Yun
林佩蓁
Lin Pei-Chen

造型總監
Costume Designer

鄧莉棋
Li Chi Deng

服裝造型
Costume Supervisor

閔慧蘭
Min I Lan

服裝執行
Costume Executive

林姿慧
Lin, Tzu Hui

服裝助理
Costume Assistant

王以琳
Ilin Wang

服裝管理
Wardrobe Supervisors

許書瑋
Hsu Shu-Wei

林詩偉
Lin Shih Wen

賴佩雯
Lai,Pei-wen

林隆龍
Tony Lin

王嘉瑩
Kiara Wang

化妝師
Make-up Artist

化妝執行
Executive Make-up Artist

黃瓊慧
Chiung Hui Huang

化妝助理
Assistant Make-up Artists

林靜怡
Jing-Yi-Lin

黃詩蓓
Huang,Shih-Bei

髮型
Hair

EROS

髮型總監
Hair Designer

黃國鎮
Andy Huang

髮型師
Hairstylists

侯誌凱
Hou, Chih Kai

張義培
Chang, Yi Pei

林詠珊
Lin, Yung Shan

梳妝助理
Hair Assistant

蘇翊晴
Yi-Qing Su

特化指導
Special Makeup Artist

儲稼逸
Chu, Chia Yi

特效化妝
Gistant to Special Makeup Artists

張甫丞
Chang, Fu Cheng

楊以君
Yang, Yi Chun

特化助理
Gistant to Special Makeup Artists

謝昀佑/Jim
Hsieh, Yun Yu

刺青指導
Tattoo Artists

李泓霆
Li, Hung Ting

葉志明
Yeh, Chih Ming

場務領班
Unit Managers

許俊平
Hsu Chum Ping

林暐勛
Lin Wei Xun

場務助理
Unit Assistants

彭士睿
Peng, Shih Jui

李居凡
Chu Fan Lee

解智賢
Jie Zhi Xian

設備
Equipment

力榮影視器材有限公司
LEE RONG FILM &TV EQUIPMENT CO.

移動攝影領班
Following Shot

郭松柏
Kuo, Sung Po

移動攝影助理
Following Shot Assistants

黃永鑫
Huang, Yung Hsin

呂偉銘
Lu Wei-Ming

張崇峰
Chang Chung-Feng

張益誠
Chang Yi-Cheng

涂健旭
Tu Chien-Hsu

徐純南
Hsu Chun-nan

黃聖峯
Huang Sheng-Feng

林柏亘
Lin Po-Hsuan

王朝祥
Wang Chao-Hsiang

王俊傑
Wang Chun-Chieh

丁冠傑
Ting Kuan-Chieh

簡國宏
Chien Kuo Hung

陳柏言
Chen, Po Yen

穩定攝影操作員
Steadicam

穩定攝影助理
Steadicam Assistant

鍾佳育
Chung, Chia Yu

航拍飛行員
Aerial photography

范勝祥
Fan, Sheng Hsiang

電 工
Grips

彭仁孟
Peng, Jen Meng

莊凱程
Chuang, Kai Cheng

司 機
Drivers

陳 旭
Chen, Hsu

林盈宏
Lin, Ying Hung

黃銘輝
Huang, Ming Hui

彭百偉
Peng, Pai Wei

鄭良富
Cheng, Liang Fu

花絮側拍
Behind The Scenes

何萱瑩
Ho,Hsuan-Ying

余素蘭
Yu, Su Lan

劇照師
Still Photographer

李孟庭
Lee Meng Ting

紀實側拍攝影師
Documentary Still photographer

Per Jansson

剪接指導
Director of Edit

姚宏易
Yao Hung-I

剪接協調
Editing Coordinator

張志杰
Mojo Chang

前期剪接 Pre-Editing	蘇珮儀 Milk Su		
剪接助理 Edit Assistants	劉人鳳 Door Liu	王聖縣 County Wang	

後期製作 / Post-production
理大國際多媒體股份有限公司
LE DAY MULTIMEDIA CO., LTD.

後期總監 Post Production Supervisor	張威縝 Red Chang		
後期製作顧問 Post Production Consultant	游信全 Yu, Hsin Chuan		
後期製作統籌 Post Producer	李若凱 Karen Lee		
後期協作 Post Production Coordinators	張志杰 Mojo Chang 張蕙蓉 Crystal Chang 林煜翔 George Lin	林小肯 Ken Lin 林瑋 Wayne Lin	李佳玲 Lei Kai Leng 林道禹 Oscar Lin
後期檔案管理 Post DIT	理大國際多媒體股份有限公司 LE DAY MULTIMEDIA CO., LTD.		
財務 Financial Managers	游信全 Yu, Hsin Chuan	陳淑芬 Chen, Shu Fen	
後期執行製片 Post Line Producers	李若凱 Karen Lee	張志杰 Mojo Chang	
後期行政業務 Post Coordinator	林小肯 Ken Lin		
字幕製作 Subtitling	李若凱 Karen Lee	張志杰 Mojo Chang	李佳玲 Lei Kai Leng
英文字幕翻譯 English Subtitle Translator	蔣明憲 Amold Chiang		

中影股份有限公司 影視製片廠 / Central Motion Picture Corporation(CMPC)

後期總監 Post Production Supervisor	林坤煌 Kun-Huang Lin
製作統籌 Post Production Producer	李志緯 Aben Lee
後期執行製片 Post Line Producer	陳力筠 Ivy Chen
後期行政業務 Post Coordinator	戴慶榕 James Tai

影像製作 / Digital Intermediate Facilities Provided by CMPC

製作指導 Digital Intermediate Supervisor	李志緯 Aben Lee	後期檔案管理 Post DIT	陳怡儒 Karen Chen
剪輯助理 Editing Assistant	周蕙瑜 Hui Yu Chou	數位剪輯 Digital on-line Editor	周蕙瑜 Hui Yu Chou
現場剪接師 On-set Editing	許哲綸 Zhe Lun Hsu	數位調光師 Digital Colorist	李志緯 Aben Lee
預告調光師 Trailer Digital Colorist	邱程勇 CY Chiu		
數位調光助理 Digital Colorist Assistants	邱程勇 CY Chiu	郭娟寧 Juan Ning Kuo	
字幕製作 Subtitling	周蕙瑜 Hui Yu Chou	DCP母源製作 Digital Cinema Package Deliverable	周蕙瑜 Hui Yu Chou
DCP數位拷貝製作 Digital Cinema Package & Duplicate	陳怡儒 Karen Chen		

聲色盒子有限公司 / 3H Sound Studio Ltd.

聲音指導 Supervising Sound Editors	杜篤之 Tu Duu-Chih	吳書瑤 Wu Shu-Yao	

對白剪接	杜亦晴	宋佾庭	劉逸筠
Dialogue Editors	Du Yi-Ching	Sung Yi-Ting	Liu I-Yun
	劉小蝶	謝青妁	詹佳穎
	Kelsey Liu	Hsieh Ching-Chun	Chan Chia-Ying
音效剪接	宋佾庭	劉逸筠	劉小蝶
Sound Effects Editors	Sung Yi-Ting	Liu I-Yun	Kelsey Liu
	謝青妁	杜則剛	張芬瑄
	Hsieh Ching-Chun	Tu Tse-Kang	Fiona Chang
ADR 錄音	宋佾庭		
ADR Recordist	Sung Yi-Ting		
Foley錄音	吳書瑤	宋佾庭	
Foley Recordists	Wu Shu-Yao	Sung Yi-Ting	
Foley音效	劉逸筠	李牧容	張家綺
Foley Artists	Liu I-Yun	Lee Mu-Rong	Chang Chia-Chi
聲音後期聯繫	宋佾庭	劉逸筠	
Sound Studio Coordinators	Sung Yi-Ting	Liu I-Yun	
混音	杜篤之	吳書瑤	
Re-recording Mixers	Tu Duu-Chih	Wu Shu-Yao	

索爾視覺效果有限公司 / SOLVFX, LLC.,

監製	王重治	VFX Supervisor	Adam Chang
Producer	Shigeharu Tomotoshi	特效製作人	林怡秀
特效總監	張朝銘		
VFX Producer	Rebecca Lin		
3D 動畫師	吳承羲	何濘	
3D Artists	Turtle Wu	Jack Ho	
特效師	黃浩銘	吳承羲	
FX Artists	Maxwell Huang	Turtle	
2D 合成師	陳冠佑	舒國豪	陳勃佑
2D Artists	Gary Chen	Zaki Shu	Yoyo Chen
	林宛柔	陳沛予	梁瑞翔
	Candy Lin	Yu Chen	Fernando Linag
	紀巧如	林玉涵	王正穎
	Ruby Ji	Myau Lin	Chen-Ying Wang
美術設計	夏楚涵		
Art Concept	Summer Hsia		

熔藝影像股份有限公司 / MagmArt VFX

特效總監	杜保賢	劉威伸	
Supervisors	Jimmy Du	Well Liu	
特效製作	王翊瑋		
Project Managers	I Wei Wang		
2D 合成師	秦鈺軒	劉文豪	王鵬豪
2D Artists	Chin Yu Hsuan	Wen Hao Liu	Peng Hau Wang
	吳建寧	葉光軒	林瑞淳
	Jian Ning WU	Shuan Ya	Ruei Chun Lin
	涂果俐	楊筱蘋	許文馨
	Painted fruit Li	Yang Xiaoping	Wenxin Xu
	陳薇宣	黃泓憲	李明杰
	Chen Wei Xuan	Huang Hongxian	Li Mingjie
3D動畫師	郭兆旺	黃造銘	
3D Artists	Aidan Guo	Zao Ming Huang	

思現影像設計 / SILK-FX

特效製作	張家豪		
ual Effects Production Manager	ETOD Zhang		
2D 合成師	江怡萱	林崑庭	馬千晨
2D Artist	Vicky Chiang	KT Lin	Stella Ma
	郭諮蓁		
	Nicole Kuo		

片尾曲 / Trailer

《悲歌》
《The song of sorrow》

演唱 Performer	JV 陳政文 Edison JV
作詞 Lyricist	JV 陳政文 Edison JV
作曲 Composer	JV 陳政文 Edison JV
編曲 Arrangers	管易昀 / 許叔男 KUAN YI-YUN / Xu Shunan
錄音室 Recording Studio	海韻音樂 Ocean Music Co,Ltd
和音 Back-up Vocal	許叔男 Xu Shunan
混音 Mixing Engineer	黃綻默 Armo Huang
弦樂 String secessionist	許叔男 Xu Shunan
錄音 Recording Engineer	黃綻默 Armo Huang
製作人 Producer	黃綻默 Armo Huang
著作權公司 OP	理大國際多媒體股份有限公司 LE DAY MULTIMEDIA CO., LTD.

《關老爺》
Dear Lord Guan

演唱 Performer	JV 陳政文 Edison JV
作詞 Lyricist	JV 陳政文 Edison JV
作曲 Composer	JV 陳政文 / 管易昀 Edison JV / KUAN YI-YUN
編曲 Arrangers	管易昀 KUAN YI-YUN
錄音室 Recording Studio	海韻音樂 Ocean Music Co,Ltd
混音 Mixing Engineer	JV 陳政文 Edison JV
弦樂 String secessionist	管易昀 KUAN YI-YUN
錄音 Recording Engineer	黃綻默 Armo Huang
製作人 Producer	JV 陳政文 / 黃綻默 Edison JV / Armo Huang
著作權公司 OP	理大國際多媒體股份有限公司 / 管易 LE DAY MULTIMEDIA CO., LTD. / KUAN

插曲 / Episode

《老大借過》
Excuse you,Boss

演唱 Performer	JV 陳政文 Edison JV
作詞 Lyricist	蔡振南 / JV 陳政文 Tsai, Chen-Nan / Edison JV
作曲 Composer	蔡振南 / JV 陳政文 Tsai, Chen-Nan / Edison JV
編曲 Arranger	海大富
混音 Mixing Engineer	黃綻默 Armo Huang
錄音 Recording Engineer	黃綻默 Armo Huang
製作人 Producer	黃綻默 Armo Huang
著作權公司 OP	南歌音樂製作有限公司 Southern Song Music Production, Ltd. 理大國際多媒體股份有限公司 LE DAY MULTIMEDIA CO., LTD.

《金包銀》
Gold and Silver

作詞 Lyricist	蔡振南 Tsai, Chen-Nan
作曲 Composer	蔡振南 Tsai, Chen-Nan
著作權公司 OP	南歌音樂製作有限公司 Southern Song Music Production,
代理版權 SP	豐華音樂經紀股份有限公司 Forward Music Publishing Co., Lt

《祝壽歌》
For your Birthday

作詞 Lyricist	涂凱傑 Gonza Tu
作曲 Composer	涂凱傑 Gonza Tu
錄音室 Recording Studio	火箭八八錄音室 Rocket 88 Studio
著作權公司 OP	動脈音樂文化傳播有限公司 Dmile Music Co. Ltd.□

《彈唱詞》
Song of the words

演唱 Performer	羅大佑 Ta You Lo
作詞 Lyricist	羅大佑 Ta You Lo
作曲 Composer	羅大佑 Ta You Lo
著作權公司 OP	大右音樂事業有限公司 TY Music Company Limited

代理版權　SP　巨擘藝術經紀有限公司　G Power Arts Management Co., Ltd.

音樂提供　Music provided by　火箭八八　Rocket 88 Music Productions

代理版權　SP　Warner/Chappell Music Taiwan Lt

錄音著作　Recording Copyright Owner　大右音樂事業有限公司　TY Music Company Limited

《趁我還會記》 While I Still Remember

演唱 Performer	荒山亮 Ric Jan
作詞 Lyricist	荒山亮 Ric Jan
作曲 Composer	荒山亮 Ric Jan
編曲 Arranger	劉浩旭 Jack Liu
錄音室 Recording Studio	火箭八八錄音室 Rocket 88 Studio
和音 Back-up Vocal	陳秀珠 Judy Chen
錄音 Recording Engineer	林唐鈺 Samuel Lin
製作人 Producer	荒山亮 Ric Jan
著作權公司 OP	動脈音樂文化傳播有限公司 Dmile Music Co. Ltd.
代理版權 SP	巨擘藝術經紀有限公司 G Power Arts Management Co., Ltd.
音樂提供 Music provided by	火箭八八 Rocket 88 Music Productions

《為你心花開》 My heart blossom for you

演唱 Performer	荒山亮 Ric Jan
作詞 Lyricist	荒山亮 Ric Jan
作曲 Composer	荒山亮 Ric Jan
編曲 Arranger	劉浩旭 Jack Liu
錄音室 Recording Studio	火箭八八錄音室 Rocket 88 Studio
混音 Mixing Engineer	劉浩旭 Jack Liu
錄音 Recording Engineer	翁偉瀚 Hanns Weng
製作人 Producer	荒山亮 Ric Jan
著作權公司 OP	動脈音樂文化傳播有限公司 Dmile Music Co. Ltd.
代理版權 SP	巨擘藝術經紀有限公司 G Power Arts Management Co., Lt
音樂提供 Music provided by	火箭八八 Rocket 88 Music Productions

行銷宣傳 /Marketing & PR
齊石傳播有限公司
Key Stone Communication Corp.

行宣總監 Marketing & PR Supervisor	尹慧文 Tina Yin
行宣統籌 Marketing & PR Coordinator	岳趙卿 Erica Yueh
行宣團隊 Marketing & PR Team	林珍竹 Rita Lin
	蔡怡 Vicki Tsai
	謝辰鈺 Cathy Hsieh

李珈泯 Eva Lee　張博然 Ryan Chang
許輔升 Sam Shiu　陳宜汝 Iju Chen
王豪 Leo Wang

理大國際多媒體股份有限公司
LE DAY MULTIMEDIA CO., LTD.

行宣團隊 Marketing & PR Team	張文旗 Simon Chang	李若凱 Karen Lee	林小肯 Ken Lin

特別感謝 / Special Thanks
本片係獲臺北市政府文化局106年度第2期補助電影製作影片
本片係獲106年第2梯次國產電影片國內創意行銷計畫補助影片
臺北市政府
台北市政府文化局　台北市文化基金會
協拍 / 贊助 / Support By / Sponsor
台北市電影委員會
新北市政府
新北市政府文化局　新北市協拍中心

緯來 FEDE
嘉裕西服
薇閣精品旅館林森館

凱勝
珍菌堂
靖天娛樂股份有限公司
臺北市私立育達高級商業家事職業學校

台新證創業投資股份有限公司
豪門世家理容名店
伸適商旅Hotel sense
首都藝術中心

NewBit TV
金星集團
龍山商旅
臺北市東方工商

台北國際藝術村	宏洲磁磚觀光工廠	車首車行	正全義肢
NN8	201	d2*MISS SEXY	元和雅
臺北市政府交通局	臺北市政府交通局公共運輸處	臺北市政府交通管制工程處	臺北市政府交通局停車管理工程處
工務局公園路燈工程管理處圓山公園管理所	臺北市政府工務局公園路燈工程管理處圓山花卉試驗中心	臺北市政府工務局公園路燈工程管理處陽明山花卉試驗中心	台北市政府工務局新建工程處
市政府都市發展局建築管理工程處	臺北市政府警察局	臺北市政府警察局中山分局	臺北市政府警察局中山分局圓山派出所
臺北市政府警察局大安分局	臺北市政府警察局信義分局	臺北市政府警察局北投分局	臺北市政府警察局內湖分局
臺北市政府警察局交通警察大隊	中山區義交大隊	萬華區義交大隊	臺北市中山區公所
臺北市中山區聚葉里	臺北市中山區新生里	臺北市中山區中庄里	臺北市中山區中山里
臺北市中山區康樂里	臺北市中山區聚盛里	臺北市內湖區公所	臺北市內湖區西湖里
臺北市大同區斯文里	臺北市信義區公所	臺北市信義區西村里	新北市政府漁業及漁港事業管理處
新北市政府農業局	法務部廉政署廉政研習中心	法務部行政執行署新北分署	艋舺助順將軍廟
珠海市吉城文化傳播有限公司	方家懷舊眷村滷味	8號髮粧造型店	聖德生命禮儀
賓王大飯店	賓王時尚旅社	錦新大樓管委會	力欣百漾社區
久泰資源回收有限公司	綠電再生股份有限公司	85度c長安東路店	大同農安大樓管委會
生福祠管理委員會	天麗髮型設計工作室	遠雄房地產晴空樹	美麗心精品旅館
信義威秀影城	Gogoro 信義威秀店	SEIKO 信義威秀店	BABE18 信義威秀店
達芙妮 信義威秀店	H:Connect 信義威秀店	Krispy Kreme Doughnuts 信義威秀店	NET主富 信義威秀店
麻膳堂 信義威秀店	吐司工坊 信義威秀店	龍波斯特Lobster.foods 信義威秀店	中華電信 信義威秀店
台灣大哥大 信義威秀店	遠傳電信 信義威秀店	Accessorize 信義威秀店	banila co. 信義威秀店
etude house 信義威秀店	莎莎國際SaSa 信義威秀店	L.A.Cafe 信義威秀店	新光三越台北信義新天地
子樂投資公司	珮斯坦咖啡館 PastTimes Cafe	CAMPUS CAFÉ	廚子市場 le marché de cuistot
財團法人福祿文化基金會北投文物館	烏來國際岩湯	沐嵐小鎮	德年國際股份有限公司
基隆中華貨櫃場	台北市協天宮管理委員會	立畜實業有限公司	富偉東泰停車場
花娘小館 敦化北店	阿波羅書廊	百利大廈	星靚點花園飯店
蘭花泰養生館	Jstar 撞球概念館	樂樂養生館	Le Fumoir威士忌雪茄館
五股休閒大釣場	富全建材有限公司	暉達機械有限公司	臺北民生四面佛佛臨舍
MH HAIR DESIGN	金員外大舞廳	GinaSu服飾店	欣欣百貨
孫中強經理	欣欣大眾市場股份有限公司	欣欣百貨Mango	欣欣百貨Roots
欣欣百貨Uniqlo	欣欣秀泰影城	漢堡王林森店	晶華酒店
礁溪武聖官將團	嘉興孝女團	希望摯尚事業有限公司	基隆長興呂師父龍獅團
黑貓時尚會館	草舍文化有限公司	台北市大同區協天宮	台北市大同區協天宮管理委員會
洋天集團	8號髮妝	台北市萬華區凌宵里辦公室	奧斯卡商務酒店
百可夢娃娃機西門店	發Q雞蛋仔	南機場一級棒燒烤	宥弘
宇宙哥	洋天雄哥	王雍文	劉志強
李文達	柯韋宏	周峻漢	方琮富
謝孝澤	地球哥	韋小寶	王竣智
位佐棋	黃信傑	陳昱州	林文漢
劉胤委	林政穎	潘俊彥	簡莉欣
劉志祥	陳增達	吳健峰	繆曉帆
徐國倫	潘珏文	林君達	卓虹伶
吳容宸	陳俊凱	黎子昀	晶華盈
林純羽	陳柏宇	邱薇臻	蔡孟言
曾祐禎	孫佳慧	呂彥萩	王若璠
林儀芬	彭小平	李肇征	黃小綺
彭孟羚	邢嚙威	趙意君	陳建佑
林懷欣	許雅涵	謝尚廷	王鈺馨
賴姿君	洪于婷	洪伶佳	廖怡君
朱庭萱	王霖	林珊伃	李欣儒
秦綺婕	張璪文	王李佳玲	潘頤仁
黃可馨	李米恩	張允	趙意君
林欣虹	陳錦威	彭至萱	黃馨慧
邱季瑾	葉晴緹	王寶慧	張瑋哲
霍怡璇	朱怡靜	莊雅姿	蘇郁喬

<center>贊助廠商 / sponsor</center>

13ink刺青店	保力達	春風	大溪金面山聖德名園
好萊塢的秘密	華生桶裝水	皇馬車業	SHADOW
金順菁仔行	美廉社	台灣啤酒	天仁茗茶
威士忌-佳樂力捷	信義計劃眼鏡	御奠園	anchus
BEMAX胖胖星球	FOSSIL	Ionism	JUSTIN DAVIS
LG	Nars	Pallamdium	東伸塑膠

<center>特別感謝 天宇宙 皇族文創 協助拍攝</center>

關於Per，以及這本書

我的名字是Per Jansson，我來自瑞典，是攝影的自學者，一開始我是在瑞典Uppsala獲得工程物理理學碩士，然後赴荷蘭的歐洲專利局工作，也在荷蘭鹿特丹完成工商管理碩士學位（MBA）。完成MBA學業後，我決定不停止我畢生的興趣——攝影，追求人們的無盡魅力及人們的樣貌與生活，所以拍攝人像是我的主要攝影工作。

於是2004年，我與瑞典援助組織SIDA合作，遠赴斯里蘭卡。

在斯里蘭卡島停火期間，我的拍攝工作遍布整個島嶼。透過我的鏡頭，描繪了在內戰期間長大的年輕領導人，在這段時間裡，我在斯里蘭卡也拍攝了茶園裡工作的人們。

在台灣，我為幾位名人進行拍攝人像工作，如楊貴媚、鄒兆龍、丁寧、康妮媚等，也與台北市文化局電影委員會和其他組織合作過。

我的作品包括CD與書本，名人肖像、活動攝影、紀錄片和我自己的個人創作。

在台灣，我得到一個非常有趣的工作機會，參與了2018年台灣電影票房破億的黑幫電影「角頭2：王者再起」。這部電影講述當地黑幫兄弟的故事，在這部電影的拍片製作過程中，我跟隨，做了側拍紀實的工作，因此，有了這本攝影書。

許多台灣的年輕男人與男孩之間，都會出現所謂的兄弟情誼，這是男孩與男人的世界，這是男性之間的友誼，友誼伴隨著忠誠、承諾。

有些brothers後來成了兄弟，成了黑社會、角頭成員，忠誠與承諾變得更加嚴苛。

然而，有些男人世界，於成長的過程依然交織在一起，如果年輕時期已有兄弟情誼，未來還會是兄弟，只是可能身處於不同的「兄弟」環境意義。對於像我這樣的（男性）外國人，以及許多的台灣人，對這種兄弟情誼是不瞭解的，除非你突然發現自己在中間，我猜我確實發現自己在那裡。我要感謝這個巨大的機會，讓我看到並遇見真實的兄弟情誼，有時我也被稱為「兄弟」；或者，就像角頭2出品人張先生所說的那樣，瑞典兄弟……

Per Jansson

About Per

My name is Per Jansson, I come from Sweden, and I am an autodidact photographer who started out with getting myself a Master of Science in Engineering Physics from Uppsala, Sweden. Went to work for the European Patent Office in the Netherlands and then achieved a Master of Business Administration (MBA) from Rotterdam, Netherlands. From this point I decided to follow my lifelong interest of photography and my endless fascination for people, their looks and their lives, and I started working as a photographer. The portrait is the central theme of my work. In Sri Lanka I worked with the Swedish aid organization SIDA. We travelled all over the island of Sri Lanka during the cease-fire in 2004 and portrayed young leaders who had grown up during civil war. During this period of time I also worked with and portrayed tea pluckers of Sri Lanka. In Taiwan I have worked with a number of celebrities such as Yang Kuei-Mei, Collin Chou, Ding Ning, Connie Mae and more. I have worked with the Taipei Film Commission and other organizations. My work includes cd-covers, celebrities, portraits, event photography, documentary and my own personal projects. In Taiwan I have also had the very interesting opportunity to work with the production of a local gangster movie which has led to this book.

Many young Taiwanese men, and boys, will be exposed to the so-called brotherhood. This is a world for boys and later for men. It is a friendship between males and the friendship come with a loyalty commitment. Some of these brothers will later become brothers within a Chinese triad and then the loyalty commitment becomes more demanding. However, the world of brothers remains intertwined as these men grow older. If you were once brothers at a young age, you will still be brothers. To a (male) foreigner such as myself, and to many Taiwanese, this brotherhood remains unknown unless you suddenly find yourself in the middle of it, and I guess I did find myself there. It has been a tremendous opportunity for me to work with, see and meet the brotherhood and sometimes be called a brother. Or, like Mr. Chang once put it, a Swedish brother...

POO0038
角頭 - GATAO

作者／攝影——Per Jansson
翻　　譯——蘇楓雅
美 術 設 計——Per Jansson
製　　作——齊石傳播有限公司
資 深 主 編——謝鑫佑
校　　對——謝鑫佑、Per Jansson
行 銷 企 畫——藍秋惠
總 編 輯——胡金倫
董 事 長——趙政岷
出 版 者——時報文化出版企業股份有限公司
　　　　　　一〇八〇一九台北市和平西路三段二四〇號
　　　　　　一～七樓
　　　　　　發行專線　（〇二）二三〇六六八四二
　　　　　　讀者服務專線　〇八〇〇二三一七〇五
　　　　　　　　　　　　　（〇二）二三〇四七一〇三
　　　　　　讀者服務傳真　（〇二）二三〇四六八五八
　　　　　　郵撥　一九三四四七二四時報文化出版公司
　　　　　　信箱　一〇八九九臺北華江橋郵局第九九信箱
法律顧問——理律法律事務所　陳長文律師、李念祖律師
印　　刷——和楹印刷有限公司
初　　版——二〇二〇年七月三日
定　　價——新台幣七五〇元
（缺頁或破損的書，請寄回更換）

時報文化出版公司成立於一九七五年，一九九九年股票上櫃公開發行，二〇〇八年脫離中時集團非屬旺中，以「尊重智慧與創意的文化事業」為信念。

角頭 - GATAO / Per Jansson文字.攝影.
-- 初版 -- 臺北市：時報文化, 2020.07
100面 ； 24.2X20.4公分
ISBN 978-957-13-8221-0(精裝)

987.83
109006959

ISBN 978-957-13-8221-0
Printed in Taiwan

POO0038
角頭 - GATAO

Author, Photographer: Per Jansson
Translator: Evelyn Su
Book Design: Per Jansson
Production: Key-Stone Communications Ltd.
Senior Editor: Hsieh Hsin Yu
Proofreading: Hsieh Hsin Yu, Per Jansson
Marketing: Corona Lan
Editor-in-Chief: Woo Kam Loon
Chairman: James C.M. Chao
Publisher: China Times Publishing Company
1-7 Floor, No. 240, Section 3,
Heping West Road, Taipei City
Distribution Issue Hotline: (02) 23066842
Reader Service: 0800 231705, (02) 23047103
Reader Service Fax: (02) 23046858
Postal Giro: 19344724
China Times Publishing Company
P.O.Box: 79~99, Taipei
Legal Counsel: Lee and Li Attorneys-at-Law C.V. Chen N.T. Li
Printer: Yongfeng Printing Co., Ltd.
First Edition: July 3, 2020
List price: NT $ 750
(In the case of damaged books, please send it back for exchange)

China Times Publishing Company established in 1975, is one of leading publishing houses in Taiwan, and it became the first and only publishing house with an IPO in Taiwan in 1999. China Times Publishing is dedicated to introducing distinguished authors and writings to readers and to preserving knowledge and culture for the future generations.

角頭 - GATAO / Per Jansson Text. Photography.
First edition-Taipei City: Times Culture, 2020.07
100 pages; 24.2X20.4 cm
ISBN 978-957-13-8221-0 (Hard cover)

987.83
109006959

ISBN 978-957-13-8221-0
Printed in Taiwan